ELIZABETH TAYLOR

1932–2011

"A prisoner's dream, a secretary's fantasy; unreal, unattainable"
—TRUMAN CAPOTE

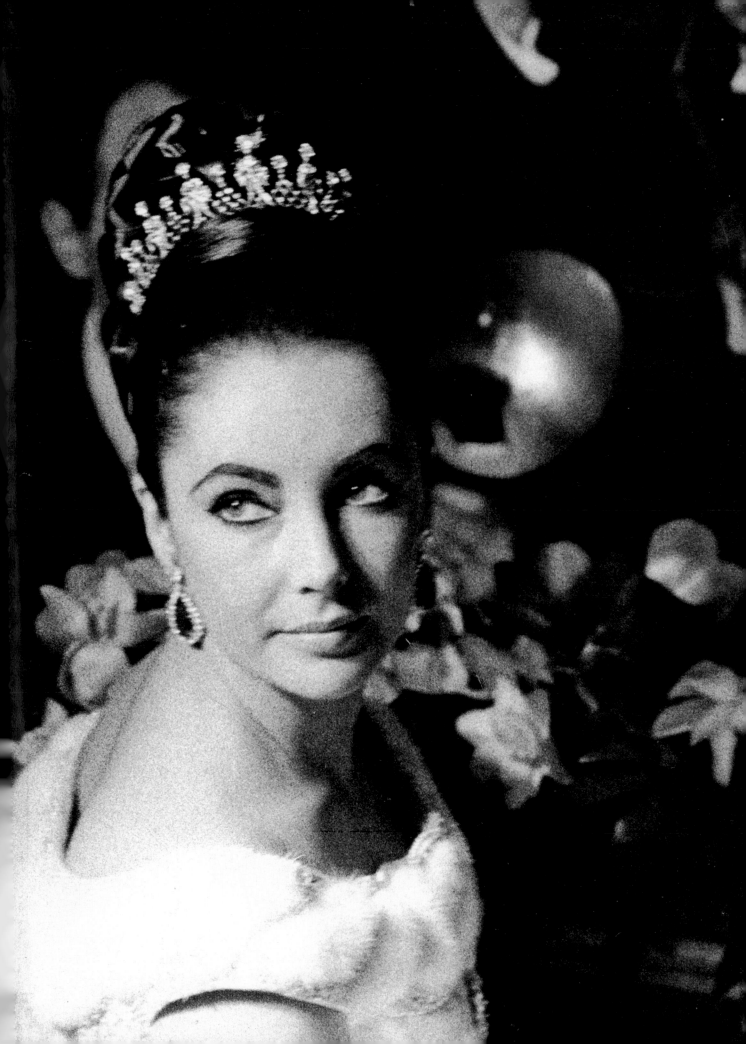

CALIFORNIA GIRL
By the time she was 15, Taylor (in a 1947 photo op) was being considered for grown-up roles. It's easy to see why.

CONTENTS

A LEGENDARY LIFE

When casting the beautiful rich girl who triggers the tragedy at the center of *A Place in the Sun*, director George Stevens was looking not for great acting but for allure. With her voluptuous figure, gleaming black hair, porcelain skin, sensuous lips and lush black lashes framing molten violet eyes, Elizabeth Taylor, at 18, was Stevens's fantasy figure in the flesh. The child star of *National Velvet* had burst into full erotic flower.

As she became an adult, her sensuality transformed her from a luminous set decoration into one of the top film stars of all time. With roles like the sex-starved antiheroine of *Cat on a Hot Tin Roof,* she became, in the words of two-time husband Richard Burton, "an erotic legend." Pampered, spoiled and hailed through the '50s and deep into the '60s as the Most Beautiful Woman in the World, she reigned as Hollywood's greatest movie queen, taking and shedding husbands—there would be seven in all—and accepting as her due jewels worthy of a monarch. Yet hers was an arduous journey, with harrowing detours into illness, addiction and heartbreak. But she survived and moved forward. Leaving behind her youth, she reinvented herself as a businesswoman and a philanthropist, raising millions for AIDS research. In today's Hollywood, where true glamour is as rare as bling that's not borrowed on Oscar night, it's hard to imagine that anyone like Elizabeth Taylor will ever come our way again.

SCREEN GODDESS
An icon by the time she was in her 20s, Taylor got her second Oscar nomination for her role as Maggie in Cat on a Hot Tin Roof.

> ❝*She looks at you with those eyes and your heart churns*❞
> —**RICHARD BURTON** on Elizabeth Taylor

THE MOST BEAUTIFUL WOMAN IN THE WORLD

Erotic and earthy, passionate and profligate, forever seductive (not to mention scandalous), Elizabeth Taylor was the last of Hollywood's great movie stars, an icon in her own time

1948

SWEET SIXTEEN

In four short years, Taylor (here, believe it or not, just an adolescent) matured from the tomboy of National Velvet into a Hollywood siren.

PHILIPPE HALSMAN/©HALSMAN ARCHIVE

"She was the most beautiful child I ever saw," said Lassie Come Home *costar Roddy McDowall, who became one of her closest friends.*

GIANT SLAYER
In Giant, *Taylor aged from 20 to 50, which she said was "the most difficult age to portray if you're 22."*

MISS TAYLOR

" *Remind me to be around when she grows up* "

—ORSON WELLES

"Rapturously beautiful"
—JAMES AGEE

1956
SEDUCTRESS
Taylor said that by the time she was 17 she'd "learned how to look sultry and pose provocatively."

> # "*She's an earthy girl as well as a sophisticate*"
> —CHARLES BRONSON

1957
CLASSIC BEAUTY

A friend once described Liz as so lovely, "it was like a punch in the stomach to see her the first time."

"I sashay up to men,"
Taylor once told LIFE
magazine, explaining
some of her appeal.
"I walk up to women."

1961
THE SCAR SEEN ROUND THE WORLD
While filming Cleopatra, Taylor came down with pneumonia and had to have a tracheotomy to save her life.

1967
'60S FLIP

"In Rome," Taylor wrote, "Richard wouldn't ever let me read what they were saying about us in the newspapers."

> *"She's like an eclipse of the sun, blotting out everyone"*
>
> —MGM PRODUCER SAM MARKS

1963
DIVA DEAREST

Elizabeth Taylor went to the opera in Paris resplendent in fur and jewels.

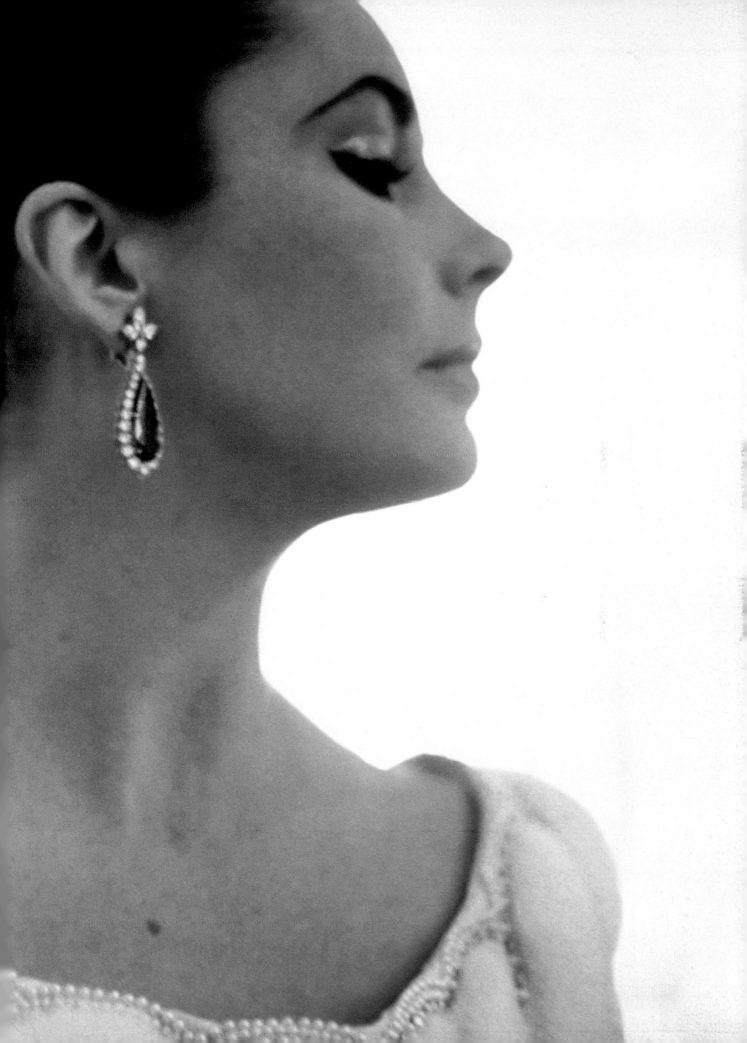

*" Every minute this broad
spends outside of bed
is a waste of time "*
—MIKE TODD

Ca. 1965

OPPOSITE
SEXY LADY
"I've only slept with men I've been married to," Taylor once declared. *"How many women can make that claim?"*

LEFT
WET AND WILD
"She's a good girl," Burton said, *"and I want us to stay together."*

21

"Her breasts were apocalyptic"

—RICHARD BURTON

1970
SHINING BRIGHT
Taylor arrived at the Academy Awards draped in the famous Taylor-Burton diamond. She had already been nominated five times and had won Best Actress Oscars for Butterfield 8 *and* Who's Afraid of Virginia Woolf?

1977

OH, THOSE EYES

Husband Richard Burton selected these amethyst-and-kunzite stones to match Taylor's legendary violet eyes.

TRUTH OR DARE?

Aside from a chin tuck, "I have not had any surgery," Liz maintained. "The next time someone asks me that question, I'm going to take all my clothes off."

"She's indestructible"
—ROCK HUDSON

1999
WOMAN IN WHITE

Living in Los Angeles with her beloved animals, the now-single Taylor still looked lovely. "I am sincerely not worried about getting old," she once wrote. "I think what age and living and experience do to one's face is beautiful."

PRETTY BABY
Soon after this photo was taken, Taylor was given her first pony: "The first time I got on her back—wearing a little organdy dress—she bucked me into a patch of stinging nettles."

SWEET BIRD OF YOUTH

In a fitting beginning to a remarkable life, Taylor found herself surrounded by stardom, love-struck suitors and family dysfunction— all before she turned 17

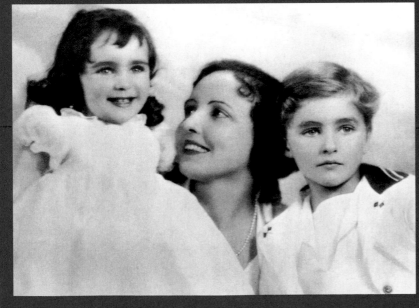

HANDSOME FAMILY
She might have been a funny-looking baby, but she looked pretty cute in 1934, posing with her mother, Sara, 38, and brother Howard, 5.

For an incredible beauty, she got off to a dubious start. Born in London on Feb. 27, 1932, Elizabeth Rosemond Taylor was described by her mother, Sara, as "the funniest-looking little baby I ever saw. Her nose looked like a tilt-tipped button, and her tiny face was so tightly closed it looked as if it would never unfold." Unfold it did. By the time her family moved to Beverly Hills in 1939, Liz had developed the blue-violet eyes that would make strangers gasp.

Though she recalled the "most idyllic childhood in England," Taylor's early life was far from perfect. Francis, her art-dealer father, was a troubled alcoholic. Sara's stage-mom aggression led to repeated standoffs with studio executives and directors. Liz inherited her determination. At 11, after an MGM casting director doubted her physical qualifications to play the lead in *National Velvet,* she promised, "Don't worry, you'll have your breasts!" The 1944 film made the preteen a household name. Making five more movies by the time she was 16, Taylor had developed into a full-blown woman, wearing clothes that accentuated the fact.

By 17, she'd been engaged to West Point football hero Glenn Davis and wealthy scion William Pawley Jr. The oddest overture came from billionaire Howard Hughes, who, the story goes, emptied a briefcase full of jewels onto a tanning Taylor and told her, "Get dressed. We're getting married." Liz declined both the man and jewels. "He was such an out-and-out bore," she later declared.

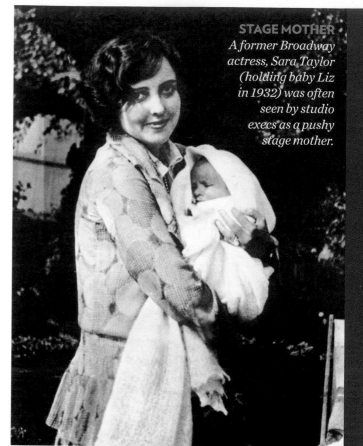

STAGE MOTHER
A former Broadway actress, Sara Taylor (holding baby Liz in 1932) was often seen by studio execs as a pushy stage mother.

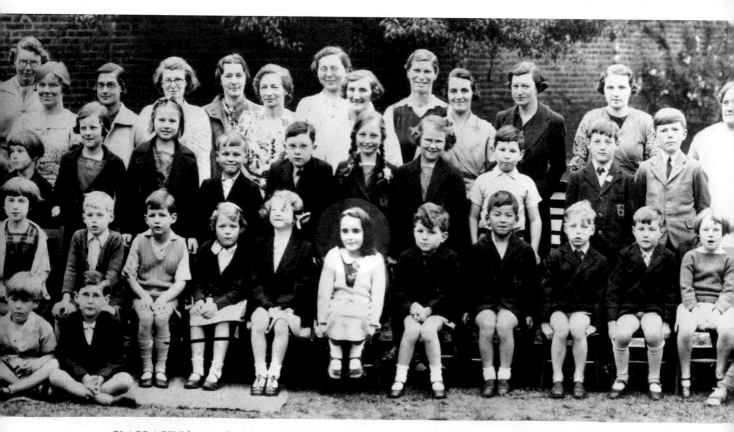

CLASS ACT *Liz posed with other pupils and teachers at her London school in 1938. The following year her family would move to the U.S. as the threat of war in Britain got more serious.*

"*I don't want to be
a movie star, I want
to be an actress*"

—**ELIZABETH TAYLOR** to her mother,
after seeing Shirley Temple in *The Little Princess*

ANIMAL LOVER
Liz, 13, with a favorite horse, Peanuts.

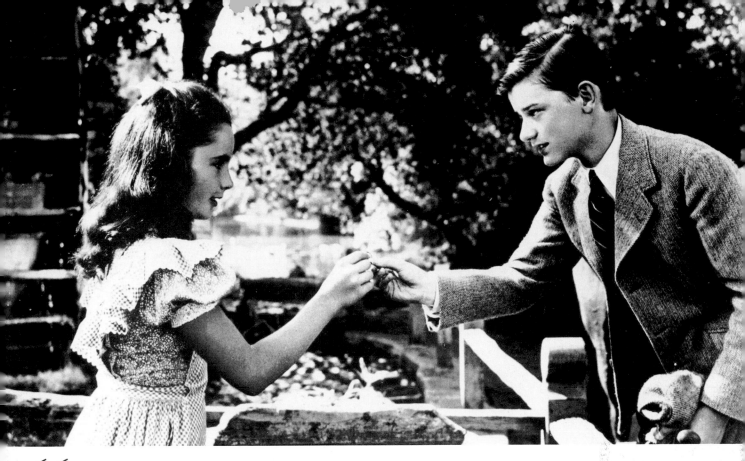

"We had no childhood. We were brought up by tutors"

—ELIZABETH TAYLOR

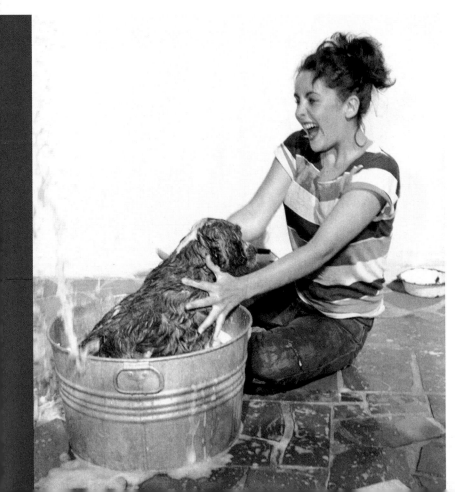

ABOVE
LIFETIME BUDDIES
Elizabeth, 11, costarred with Roddy McDowall, 15, in Lassie Come Home *in 1943. The two remained great friends until his death in 1998.*

LEFT
GIRL'S BEST FRIEND
Liz loved animals. Over a lifetime, her extensive menagerie included rabbits, snakes, ducks, an owl and several dogs and cats. As a teenager she once said that she sometimes wished for a more normal adolescent life that included activities like drive-in dates.

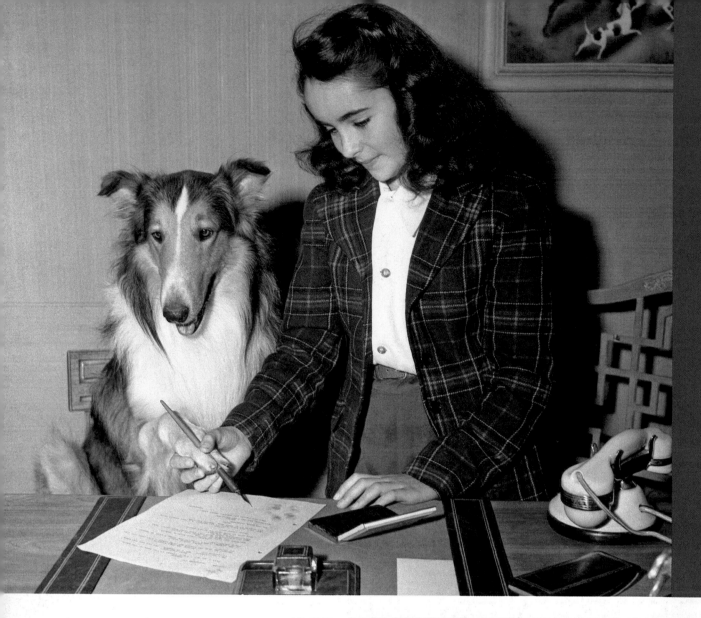

ABOVE
PAW PALS
Young Liz helped Lassie, who was then more famous than she, ink a five-year deal with MGM at $250 a week. Even though her own salary started at $100 a week, there seemed to be no hard feelings.

RIGHT
ON THE AIR
As an up-and-coming Hollywood talent, Taylor performed on the CBS radio broadcast Screen Guild Players *in April 1946. Radio didn't even begin to capture the attributes that would make her famous.*

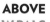

CAREER
TAKES WING
At 16, Liz returned
to London for her first
English shoot (here
in Trafalgar Square,
for Conspirator).

IDO! IDO!

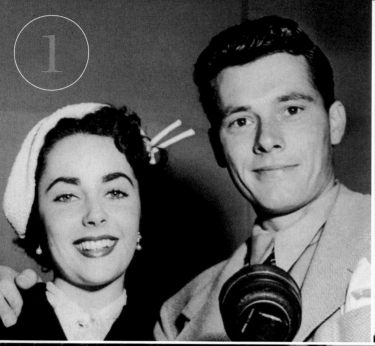

①

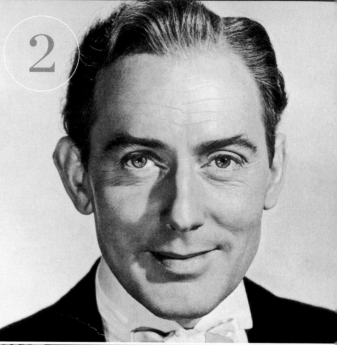

②

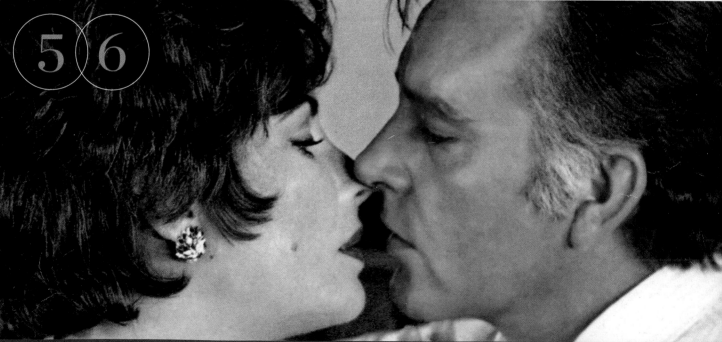

⑤⑥

"I want to be a great actress, but most of

Taylor began young, at 18, and got off to a bad start.
Bruised but undaunted, she tried again. And again. And again.
After her eighth marriage, she called it quits.
For her, the perfect union remained elusive

all I really want to snare a husband **99**

> **"Turn on your siren, let them know I'm coming"**
>
> —**TAYLOR** to police escort

1
Conrad HILTON

May 1950–February 1951

THE FIRST MR. WRONG
Guests at the first wedding included Bing Crosby, Fred Astaire and Father of the Bride *costar Spencer Tracy.*

He'll make a nice first husband," a Hollywood wit joked as the starry-eyed teen lead of the upcoming *Father of the Bride* wed tall, handsome, bottomlessly wealthy hotel heir Conrad Nicholson "Nicky" Hilton Jr. The nuptials came shortly after Liz, 18, had graduated from high school, yet Miss Lizzy was dizzy in love and woefully unschooled in what was to be her life's major—men. Had she done her homework, she would have learned that her groom, 23, was a gambler and drinker with a penchant for violence. Soon she found out. During a voyage aboard the *Queen Mary,* Hilton flew into a rage and punched his bride in the stomach. By the end of the three-month honeymoon, much of it spent in casinos, the bride had lost 20 lbs. and tried to hide the bruises. "Even the croupiers felt sorry for me," she later admitted. Hilton groused, "I didn't marry a girl. I married an institution." But the abuse continued sporadically until Liz filed for divorce less than seven months after they wed. Before his death 19 years later of a heart attack at 42, Hilton had two more ex-wives, one of whom charged physical abuse.

> *"It's a leap year,
> so I leaped"*
>
> —**TAYLOR** on why she proposed to Wilding

NUCLEAR FAMILY
*Wilding and Taylor
with sons Michael and
Christopher ca. 1955.*

2 Michael WILDING

February 1952–January 1957

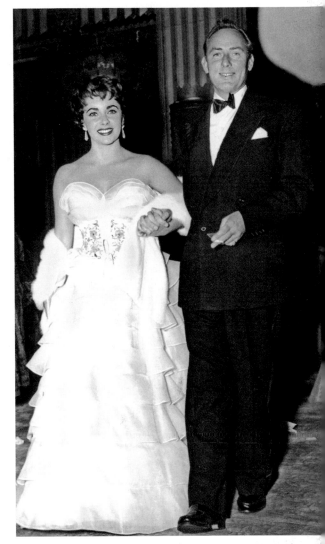

English actor Michael Wilding seemed a bit overwhelmed by his young bride. Taylor had met Wilding when she was 15, nursed a crush on him—and had even popped the question. Stepping out of the London registry office where they were married Feb. 21, 1952—six days before her 20th birthday and barely a year after the end of her first marriage—the mild-mannered Wilding, 39, appeared stunned by a mob of fans. The marriage proved one of Elizabeth's longer unions, producing children Michael in 1953 and Christopher two years later. But while Wilding devotedly waited on her during her many illnesses, Taylor grew bored. Worse, as her career soared, he turned to drink. In January 1957, Liz, then 24, asked for a divorce. She had a compelling reason: She was already pregnant by producer Mike Todd. Wilding, nice guy to the end, kindly obliged, flying to Acapulco for a quickie divorce. Two days after it was granted, Taylor became Mrs. Mike Todd.

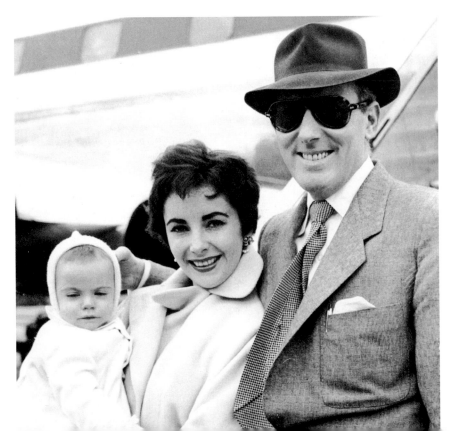

ABOVE
OSCAR GLITTER
Wilding escorted his young wife to the Academy Awards in 1953. "Michael is just a child at heart," Taylor gushed. "I think everything about him is wonderful. I adore him!"

LEFT
FLYING HIGH
The Wildings (with baby Michael) were happy travelers in 1953. Friends said it was her "struggle to become an adult" that split them apart. After their divorce, Liz was granted custody of the two boys for nine months of each year. The parents would remain friendly until Wilding died at 66 in 1979.

TRUE PASSION
"I loved him so much and he loved me," Liz said of Todd (at the 1957 Cannes film fest). *She called him one of the two great loves of her life.*

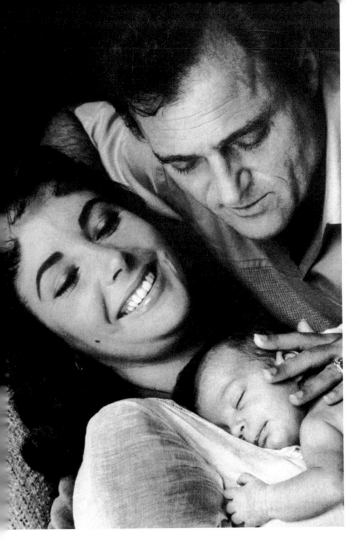

Mike TODD

February 1957–March 1958

Taylor thought her third marriage would be the charm. Just 48 hours after her divorce from Wilding, Liz, 24, wed *Around the World in 80 Days* producer Mike Todd, 49, at an Acapulco estate. Eddie Fisher was best man, and his wife, Debbie Reynolds, was a bridesmaid. Liz said being courted by Todd was like "being hit by a tornado" and fought with him over everything from her tardiness to her spending. But the match was passionate and produced daughter Liza. "When we are separated," Liz wrote, "we die." She planned to join Todd on a flight east on March 21, 1958, but was sick. The next morning their plane, *The Liz*, crashed over New Mexico. Widowed at 26, Taylor was consoled by Reynolds and Fisher.

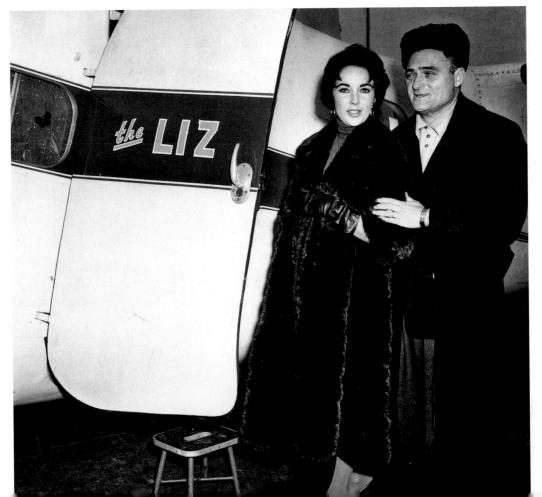

ABOVE
LOVE CHILD
Taylor and Todd's only child, Liza, was born Aug. 6, 1957, six months after the wedding. She was not even a year old when her father died.

RIGHT
FATEFUL FLIGHT
On the night Todd was scheduled to fly to New York City for a Friars Club event at the Waldorf Astoria, Taylor was too sick to join him. Their private plane, The Liz, went down over New Mexico, killing everyone onboard.

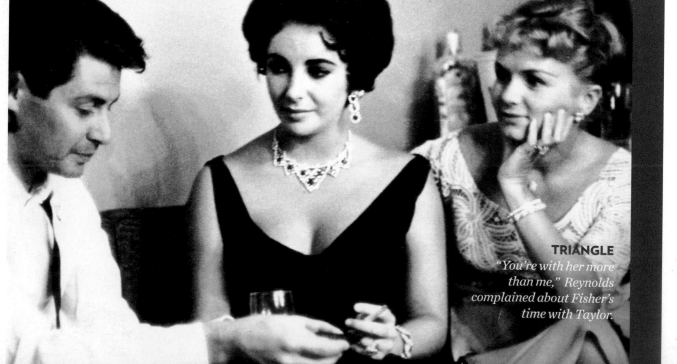

Eddie FISHER

May 1959 – February 1964

Eddie Fisher's smooth style and silken pipes had carried him from the pop hit parade to his own prime-time TV show and marriage to America's sweetheart, *Singin' in the Rain* star Debbie Reynolds. They seemed to be Hollywood's model couple, balancing family life with a social whirl, often with Mike Todd and Taylor. After Todd's death, Fisher, 29, quickly moved from comforting his friend's widow to full-body contact, and by the fall of 1958 the world was faced with its first great Liz Taylor Sex Scandal. Headlines branded Liz, 26, a home wrecker and Fisher a heel. When Fisher's Las Vegas divorce was granted on May 12, 1959, he wed Taylor later that day. Unbowed by notoriety, Liz won her first Oscar, but Fisher's popularity plummeted. Like Wilding before him, he became his wife's gofer. The marriage that began in scandal was to end in a far bigger one as Taylor filmed *Cleopatra* with Welsh actor Richard Burton.

LEAN ON ME
By the time Liz was filming Cleopatra, *Truman Capote had dubbed Fisher "the Busboy."*

TRIANGLE
"You're with her more than me," Reynolds complained about Fisher's time with Taylor.

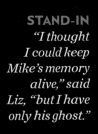

Richard BURTON

March 1964–June 1974
October 1975–July 1976

Rome's paparazzi were on high alert as "Britain's Brando" and Hollywood's voracious man-eater prepared to meet on the set of *Cleopatra.* Burton initially dismissed her as a "fat little tart," while Liz, ensconced in a villa with husband Eddie Fisher and children, vowed that she would "be the one leading lady that Richard Burton would never get." Well, vows were never her strong suit. "I get an orgasm just listening to that voice of his," Liz confessed after catching Burton in rehearsal. Like a teenager, Burton announced his intention to sneak onto the closed set for her nude scene. Once the sequences between Burton's Marc Antony and Liz's Cleopatra began shooting, the actors' passions overheated, and soon the stars, their spouses and the world's press were consumed in the conflagration.

If making headlines was a circus act, then Liz and Dick were the center ring of the early 1960s. The stars drank, fought and shopped to excess. Their epochal binges often began at breakfast and continued deep into the night. Consumed by guilt for cheating on his wife, Sybil, Burton repeatedly broke it off with Taylor, who became hysterical. After she was hospitalized in 1962 for a reported suicide attempt, he eased the pain with a $150,000 emerald brooch from Bulgari. Shooting the disastrous *Cleopatra* dragged on for over two years, giving the couple ample time to sever their respective marriages. In Montreal in March 1964, Burton, 38, became Husband No. 5 for Taylor, 32. "This marriage will last forever," she gushed.

It didn't, of course, but it did set the record: 10 years, three months, not to mention nine films together. *Who's Afraid of Virginia Woolf?* earned her an Oscar

" *We were like magnets* "

—**LIZ** about Dick

ANIMAL
MAGNETISM
*"I cannot act with
a person unless
I'm powerfully
sexually interested,"*
Burton once said.

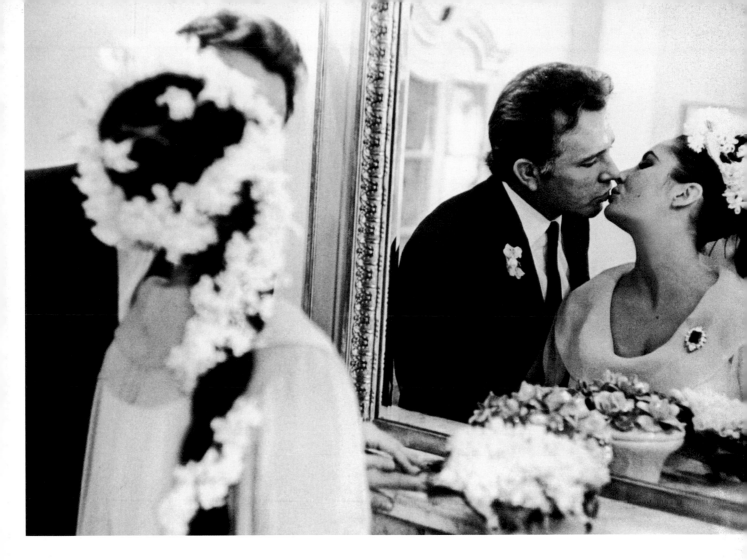

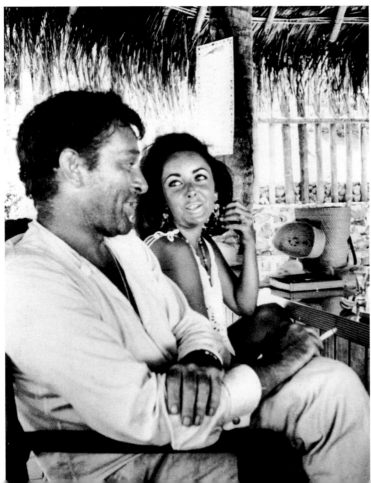

and Burton a nomination, and it was their last great performance before their long mutual decline. They separated, reconciled a few times and finally divorced in Switzerland in June 1974. After little more than a year apart, Liz and Dick married again in the African outback. "Sturm has remarried Drang," a reporter quipped.

Burton's drinking and wandering eye doomed the second attempt and they divorced after less than 10 months. Still, they remained bound together, and in 1984, when Burton died in Switzerland at 58 after a cerebral hemorrhage, Taylor was inconsolable.

ABOVE
LOVE WAITS
"I swear she'll be late for the Last Judgment," Burton said when Liz was *45 minutes late for their wedding.*

LEFT
HEAT WAVE
Burton starred in Night of the Iguana, *playing a defrocked clergyman leading a group of Baptist women on a tour of Mexico. "I envied his Shakespearean background,"* Taylor *admitted, "and the fact that he was not a movie star but a genuine actor."*

"When I please Richard, there is nothing that makes me happier"

—ELIZABETH TAYLOR

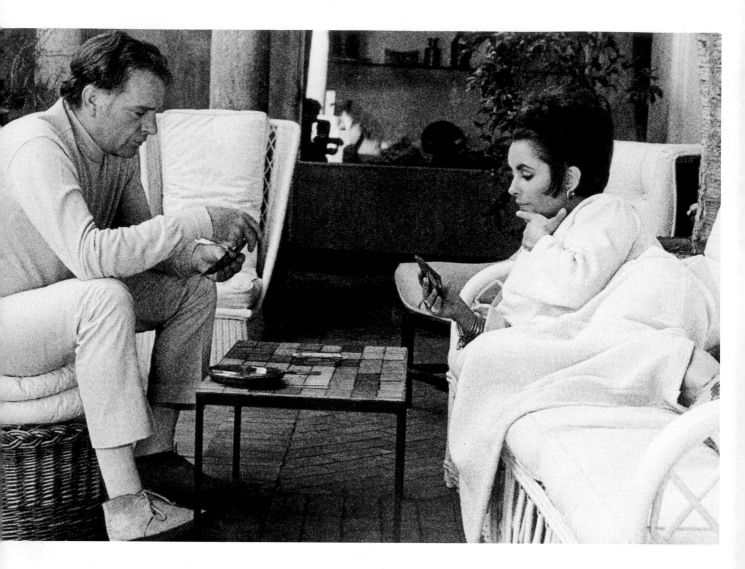

ABOVE
RARE TRANQUILITY
The couple played gin while on vacation in Saint-Jean-Cap-Ferrat, France. "I am now above and beyond anything else a woman, and that's infinitely more satisfying than being an actress," Taylor declared after marrying Burton.

RIGHT
IN TRANSIT
Burton and Taylor took all her children (left to right: Maria, Christopher, Michael and Liza) on a family outing.

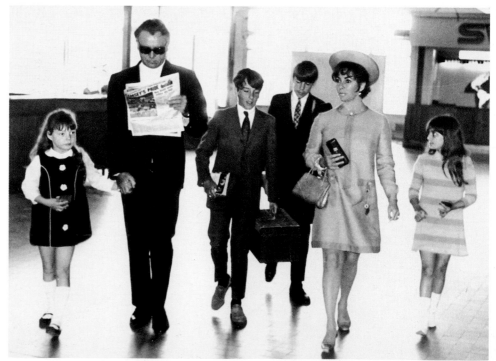

THE SANDPIPER Burton and Taylor were paid $1.75 million each for the 1965 movie. "If I were you," critic Judith Crist told readers, "I wouldn't settle for less for watching them."

7 John WARNER

December 1976–November 1982

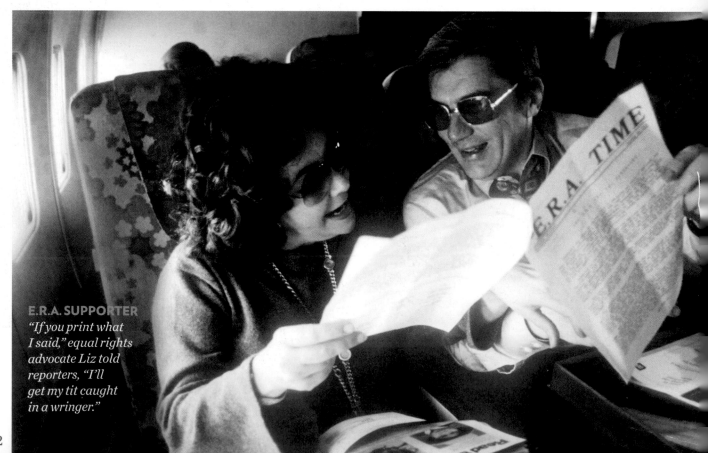

When Richard Burton wed model Suzy Hunt as soon as his divorce was final, Liz, 44, quickly followed suit. After a few dates, U.S. Senate hopeful John Warner, 49, proposed on his Virginia estate. The Hollywood libertine and the conservative Republican seemed to be strange bedfellows, but Liz was a trouper on the campaign trail. She pressed so much flesh that she popped blood vessels in her hand. Once in Washington, Warner's workaholic ways left Liz feeling so depressed that she ate and drank her way to 180 lbs. When her figure became a mockery—she was dubbed National Velveeta in *Esquire*—she shed 40 lbs. for a Broadway production and split from Warner after six years of marriage.

HAPPY TRAILS
Taylor schmoozed with voters, ate rubber chicken—and got Warner elected.

E.R.A. SUPPORTER
"If you print what I said," equal rights advocate Liz told reporters, "I'll get my tit caught in a wringer."

ODD COUPLE
Warner offered security and dignity, but Taylor, far from Hollywood pals, was not cut out to be a Washington wife.

WHEN LARRY MET LIZZIE
"It may not look like we had a lot in common," Taylor told Larry King in 2001, "but he was a very sweet, gentle man who wanted to experience life. Then something happened. He had OCD [obsessive compulsive disorder] and didn't want to leave the house."

Larry FORTENSKY

October 1991–October 1996

After her divorce from John Warner, Liz announced, "I'm a lady on the loose. I will never marry again." For nearly a decade she maintained her resolve, dating a succession of non-Hollywood types, including Watergate reporter Carl Bernstein and attorney Victor Luna. Then, in 1988, Taylor met teamster Larry Fortensky during her stay that year at the Betty Ford Center. The romance between Liz, 56, and her hunky "Handyman," as more cynical gossips called her blue-collar beau, took root after the two left rehab. Fortensky, 36, a $20-an-hour trucker and 10th-grade dropout, settled into her Bel Air home. "This is it!" Liz announced before marriage No. 8—a surreal $1.5 million affair at her friend Michael Jackson's Neverland ranch. Quickly, however, they felt the strains of their wildly divergent backgrounds and lifestyles, coupled with her health problems and his lack of career outside of being her helpmate. They moved first to separate bedrooms, then, in 1996, to divorce. Once again Liz declared that she was "through with marriage." And this time, after eight tries with seven husbands, she meant it.

BELOW

THE LAST HUSBAND

"I don't know, honey," Liz told a reporter who asked why she married so often. "It sure beats the hell out of me." Fortensky lasted five years, and then there were none.

PULP FICTION

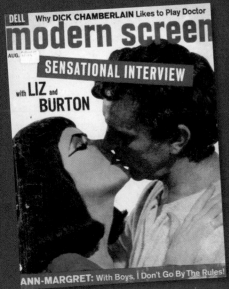

Before Brangelina there were Liz and Dick—
and they were world-class. In terms of ink
expended, Le Scandale probably rivaled
Sputnik and the Cuban missile crisis. Their
affair was condemned by the Vatican and U.S.
Congress. Every move was captured by a thou-
sand telephoto lenses for the tabloids and fan
mags. "I know they're full of baloney," said Tay-
lor. "I still read every one I can scrape up."

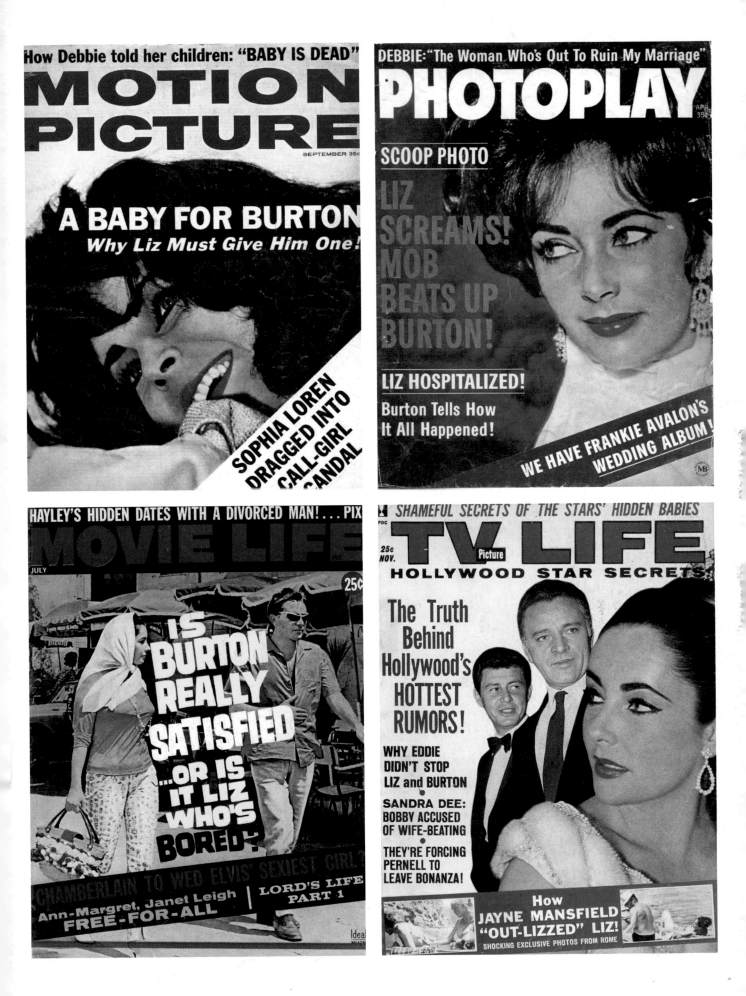

How Debbie told her children: "BABY IS DEAD"

MOTION PICTURE

SEPTEMBER 35¢

A BABY FOR BURTON
Why Liz Must Give Him One!

SOPHIA LOREN DRAGGED INTO CALL-GIRL SCANDAL

DEBBIE: "The Woman Who's Out To Ruin My Marriage"

PHOTOPLAY

APR 35¢

SCOOP PHOTO

LIZ SCREAMS! MOB BEATS UP BURTON!

LIZ HOSPITALIZED!

Burton Tells How It All Happened!

WE HAVE FRANKIE AVALON'S WEDDING ALBUM!

HAYLEY'S HIDDEN DATES WITH A DIVORCED MAN! . . . PIX

MOVIE LIFE

JULY

25¢

IS BURTON REALLY SATISFIED ...OR IS IT LIZ WHO'S BORED?

CHAMBERLAIN TO WED ELVIS' SEXIEST GIRL?

Ann-Margret, Janet Leigh FREE-FOR-ALL

LORD'S LIFE PART 1

SHAMEFUL SECRETS OF THE STARS' HIDDEN BABIES

PDC

25¢ NOV.

TV Picture LIFE
HOLLYWOOD STAR SECRETS

The Truth Behind Hollywood's HOTTEST RUMORS!

WHY EDDIE DIDN'T STOP LIZ and BURTON

SANDRA DEE: BOBBY ACCUSED OF WIFE-BEATING

THEY'RE FORCING PERNELL TO LEAVE BONANZA!

How JAYNE MANSFIELD "OUT-LIZZED" LIZ!
SHOCKING EXCLUSIVE PHOTOS FROM ROME

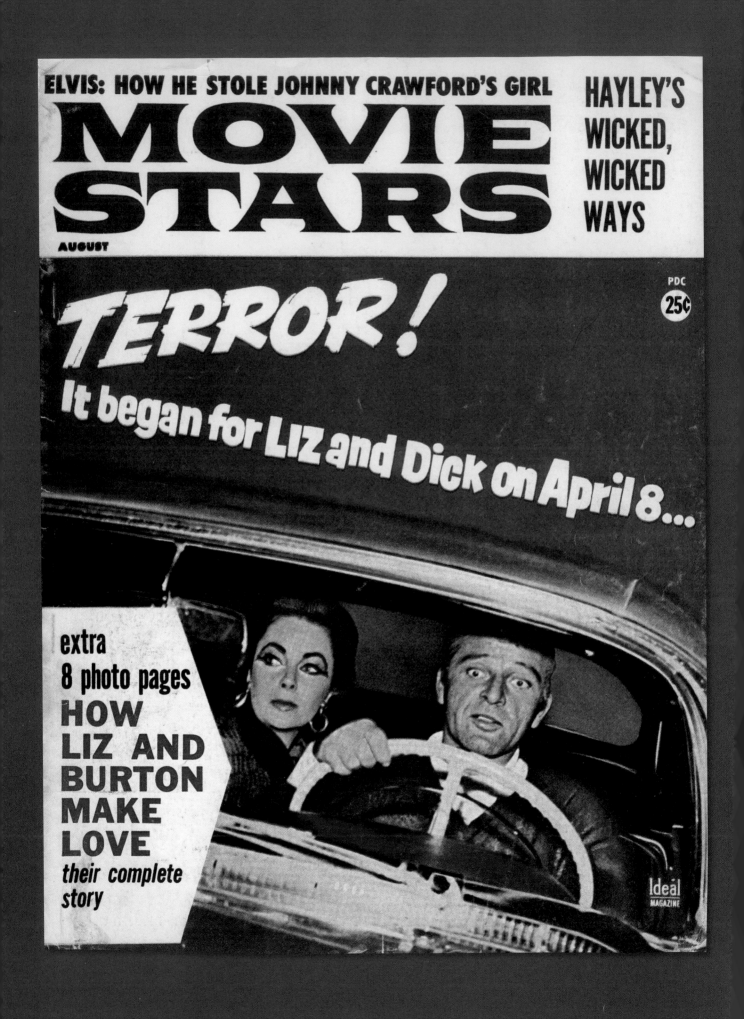

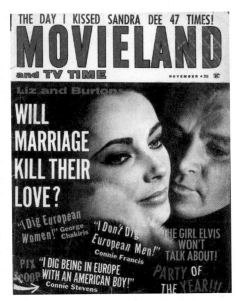

THE DAY I KISSED SANDRA DEE 47 TIMES!

MOVIELAND
and TV TIME
NOVEMBER • 25c

Liz and Burton

WILL MARRIAGE KILL THEIR LOVE?

"I Dig European Women!" George Chakiris

"I Don't Dig European Men!" Connie Francis

THE GIRL ELVIS WON'T TALK ABOUT!

PIX "I DIG BEING IN EUROPE WITH AN AMERICAN BOY!" Connie Stevens

PARTY OF THE YEAR!!!

The Day Jack Kennedy Cut Peter Lawford Dead

MOTION PICTURE
DECEMBER

UNFORGETTABLE INSIDE STORY!

HOW LIZ TERRIFIES HER CHILDREN WITH BURTON

EXCLUSIVE COLOR PORTRAIT
Connie Stevens In Her Wedding Dress

CONNIE'S OWN STORY: "My Thrills As A New Bride"

DELL EXCLUSIVE! THE BEATLE WHO ALMOST STOPPED RINGO'S MARRIAGE

modern screen
Giant HOLLYWOOD GOSSIP issue
MAY 35c

LIZ MAKES SYBIL'S FATAL MISTAKE!

WHY THE COMMUNISTS ARE OUT TO GET ROCK HUDSON
Hollywood's Most Incredible Story!

JULIE ANDREWS' Private Agony

STILL ONLY 25¢

ELVIS: MUST I SIN AS MARLON DID?

MOVIE STARS
JUNE Ideal Magazine

How Liz Makes Sure HE'LL NEVER WANT ANOTHER WOMAN

in color
DAVID McCALLUM JILL IRELAND
50 WONDERFUL PIX

JOHN WAYNE'S PHOTO LIFE

BURTON AND LIZ

DORIS DAY'S COMPLETE LIFE STORY!

MAY

TV and movie screen
25¢

CAN LIZ KEEP BURTON AWAY FROM OTHER WOMEN?

ANN-MARGRET: "I NEED A MAN!"

Judy Garland-Glenn Ford: CRAZY IN LOVE—BUT THEY CAN'T MARRY

MOTION PICTURE FOR AUGUST, 1962 • 25 CENTS

Love-Torn LIZ Her NEW CRISIS!

EDDIE FISHER'S MOTHER: "It's a Horrible Heartache!"

MOTION PICTURE
first and best

LOVE STORY OF THE YEAR!

The Behind-The-Scenes Story of Jackie Kennedy's Courtship

STILL ONLY 25¢

The One Actor Jackie Would Wed!

MOVIE LIFE
MAY PDC

"LIZ WOULD KILL HERSELF IF"... a startling story from DEBBIE

FIRST TIME McCALLUM-VAUGHN LIFE STORIES!

ROBERT VAUGHN LIZ TAYLOR

MAY 1966 35c

TEEN
Trends

SEAN CONNERY: THE "BOND" THAT IS WRECKING HIS MARRIAGE

MIA FARROW: THE STORY NOBODY WILL BELIEVE

SPECIAL SECTION STRANGE LOVE CODE OF HOLLYWOOD TEENS

WHY BURTON'S DAUGHTERS SAY—LIZ RUINED THEIR REPUTATION!

CAROL LYNLEY: The Shocking Things She Threatens To Do!

TV and movie screen
FEB ONLY 25¢

BURTON ENDS IT ALL!

EXCLUSIVE PHOTOS!

CHAMBERLAIN: WHY HE JILTED CLARA RAY

THE RINGMASTER
At home in 1957 with her sons Michael and Chris, Liz beamed at Mike Todd. Before her second divorce was final, Todd had given Liz a 29.4-carat ring she liked to call her "ice-skating rink."

TAYLOR MADE

Maybe motherhood wasn't her best role, but she performed it as well as she could, raising four children with multiple husbands. Once grandchildren arrived, she even got good at it

YOUNG AT ART
Taylor's children (left to right) Maria, Christopher, Michael and Liza (in 1964).

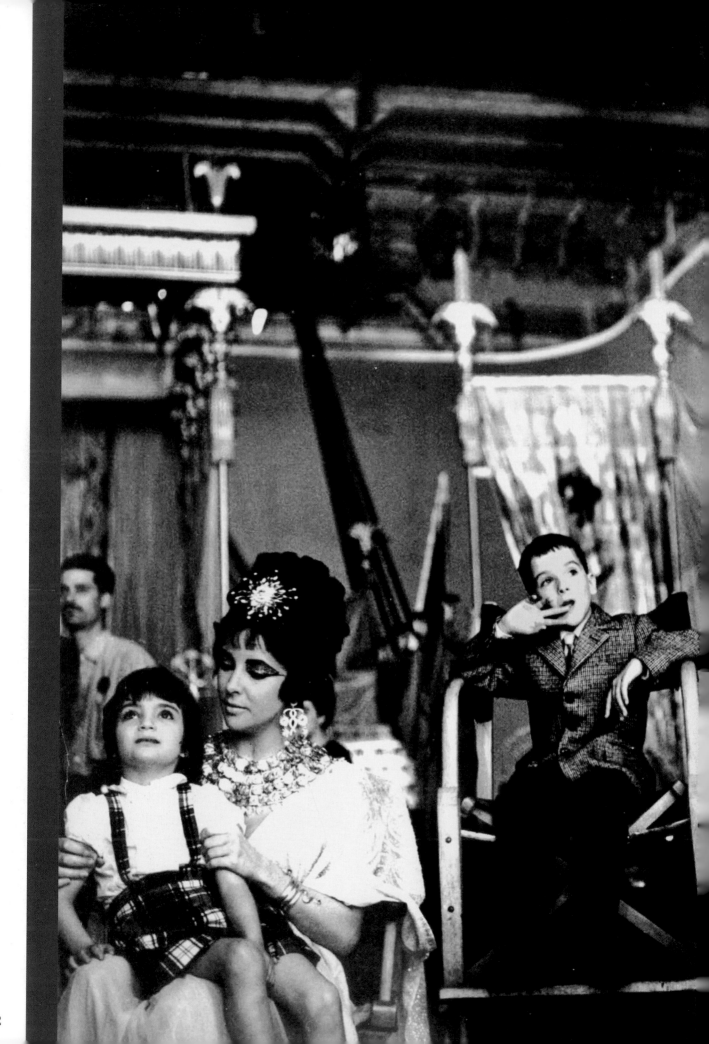

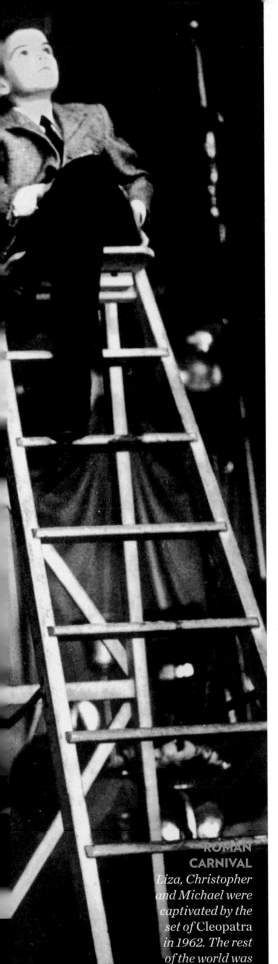

Raising her family was a challenge for the star, both physically and logistically. Her first son, Michael Wilding, was born in the same Santa Monica hospital room as Shirley Temple. After delivering his brother Christopher by C-section, Taylor was told that another pregnancy could be life-threatening. She ignored her doctor's orders, though, and became pregnant by Mike Todd; daughter Liza was nearly stillborn in 1957. Afterward Taylor had her tubes tied to prevent further conception. Then, in 1964, she adopted a 3-year-old German orphan she named Maria. But the paperwork was barely complete when Taylor divorced then-husband Eddie Fisher for Richard Burton, who became the child's legal father.

The kids resiliently survived Mom's jet-setting lifestyle and a succession of father figures and caretakers. "We lived like gypsies," said Taylor, conceding the strain of her travels on the family. As the boys got older, they were enrolled in a British boarding school, while the girls were educated in Switzerland.

Considering their upbringing, all four of her kids grew into fairly normal adults. The oldest, Michael Howard Wilding (the middle name in honor of Elizabeth's brother), tried acting and eventually became a sculptor. His brother Christopher, once married to oil dynasty heir Aileen Getty, works as a film editor. Liza Todd Tivey, who never knew her father, is an accomplished sculptor who specializes in horses. Maria Burton Carson is a philanthropist whose son is named Richard after the only father she ever knew.

By all accounts, the extended clan remained close. As the years went on, Taylor became more family-oriented, acknowledging her past inattentiveness and doting on her 10 grandchildren and four great-grandchildren. At a ceremony honoring Taylor in 1989, Michael said, "I'm proud to say that that lady is my mother."

ROMAN CARNIVAL
Liza, Christopher and Michael were captivated by the set of Cleopatra *in 1962. The rest of the world was scandalized by Liz and Dick.*

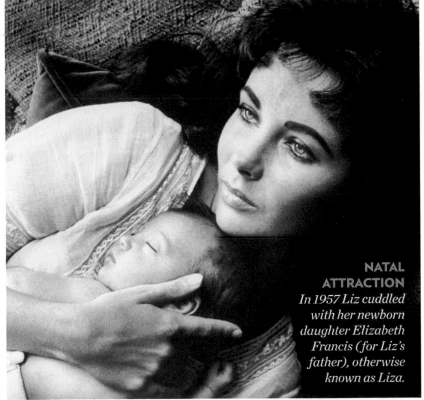

NATAL ATTRACTION
In 1957 Liz cuddled with her newborn daughter Elizabeth Francis (for Liz's father), otherwise known as Liza.

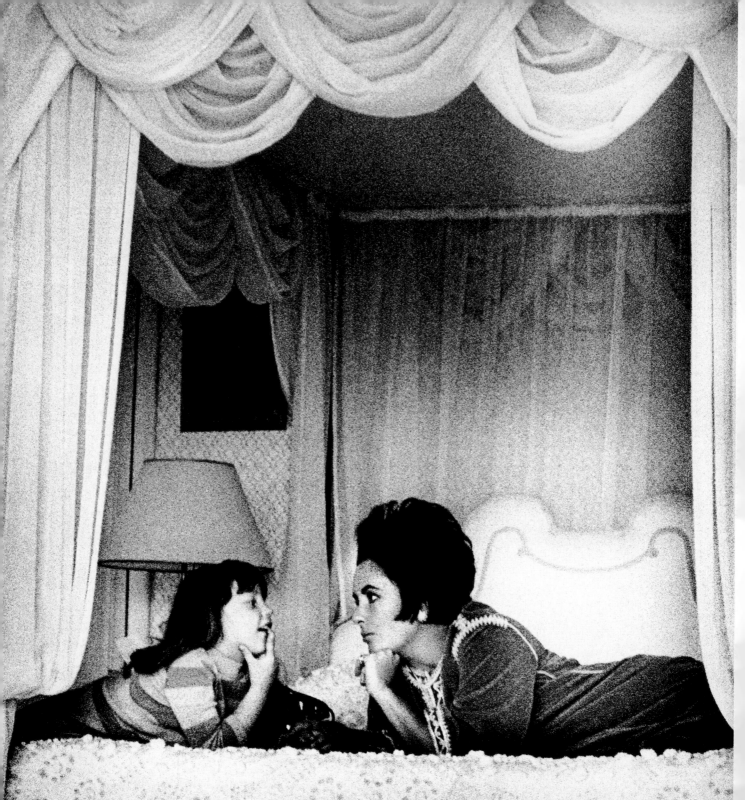

THE EYES HAVE IT
Taylor, 35, and Liza, 5, faced off in a friendly staring contest during a 1967 vacation at La Fiorentina in Saint-Jean-Cap-Ferrat, France.

HE TARZAN
Mother and Michael looked Wilding in their matching leopard-print bathing suits, ca. 1955.

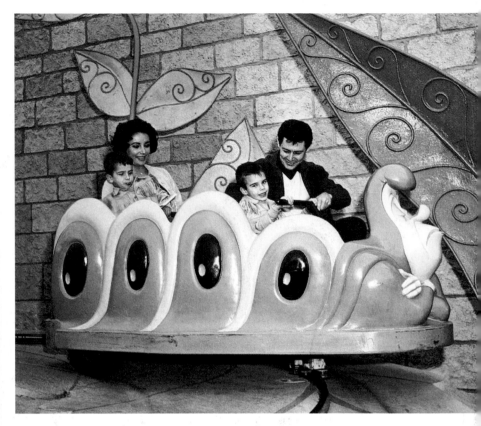

ABOVE IT'S A SMALL WORLD *Elizabeth (holding Christopher, 4) and Eddie Fisher (with Michael, 6) enjoyed a 1959 family outing to Disneyland.*

GROWING FAMILY
Maria Burton, Michael Wilding with wife Beth and baby Leyla, Liza Todd and Christopher Wilding in 1971.

LEFT
DOWN MEXICO WAY
Richard Burton cooled off in the ocean with Liz and stepdaughter Liza Todd during the 1963 filming of Night of the Iguana.

BELOW
MOVEABLE FEAST
The Taylor/Burton family sat down to eat in 1965 (from left): Michael Wilding, Liza Todd (behind Michael), Kate Burton, Chris Wilding and the parents.

OPPOSITE PAGE
ALL IN THE FAMILY
Liz went on holiday in 1967 surrounded by her clan (clockwise): Liza, Michael, Richard, Christopher and Maria. The boys were enrolled in a British boarding school, while the girls studied in Switzerland.

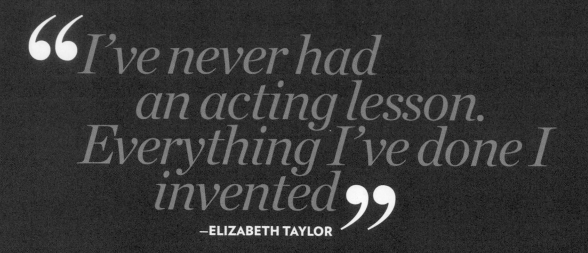

SCREEN QUEEN

One of the last great movie stars, Taylor leaves a legacy of classic—
and a few infamous—performances that are truly unforgettable

BIG SPLASH
On the set of Suddenly Last Summer, *Taylor displayed the sensuality and sex appeal that made her a top box office star.*

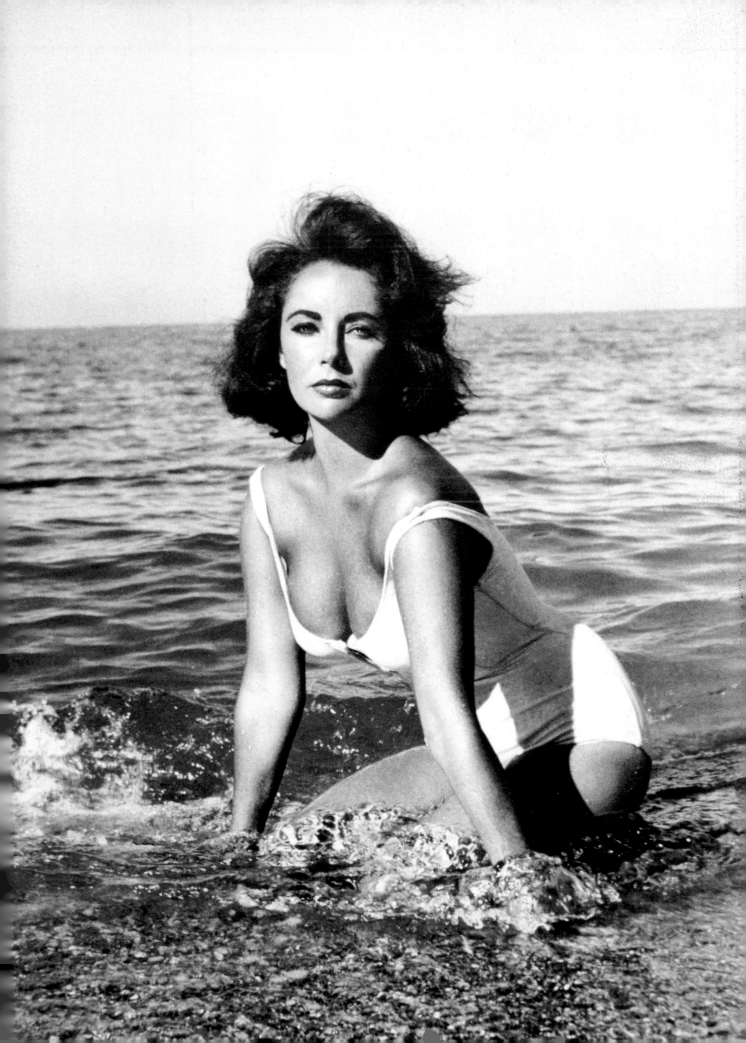

National Velvet

1944

The 12-year-old Taylor gave one of the most charming child performances in movie history. Paired with Mickey Rooney as a young ex-jockey who becomes her friend and coach—he was 24 at the time—she played an English village girl who rides her horse all the way to the finish line of the famous Grand National. Her rhapsodic love for her horse, The Pie, is tearfully touching when he bolts upright after a long illness and a joyful Taylor races to tell her family the good news.

RIDING HIGH
Taylor, atop The Pie, kidded with a crewman between takes.

Father of the Bride

1950

Taylor was still a teenager when she was cast in Vincente Minnelli's comedy *Father of the Bride*. Fact and fiction began to blur, though, when Taylor and Nicky Hilton announced their engagement as filming wrapped. MGM released the movie just after Liz's big day, practically stage-managing the wedding. Studio Chief Louis B. Mayer gave her the gown; Edith Head designed her going-away outfits.

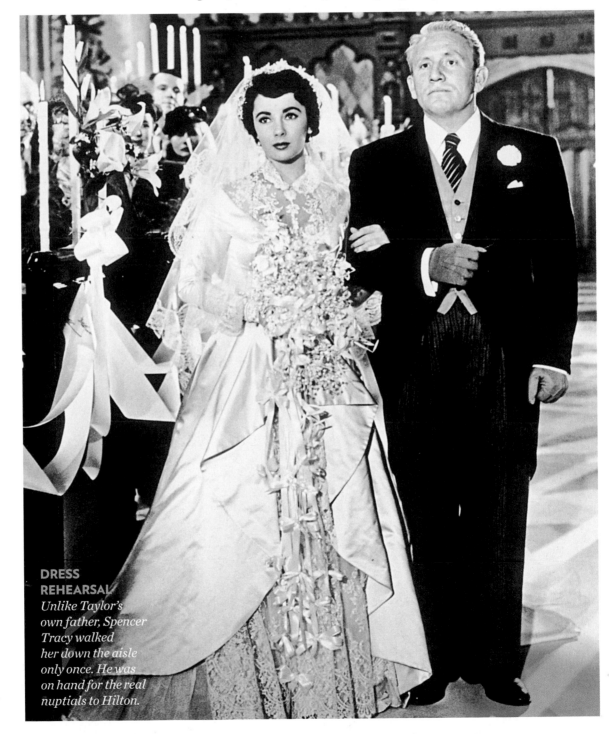

DRESS REHEARSAL
Unlike Taylor's own father, Spencer Tracy walked her down the aisle only once. He was on hand for the real nuptials to Hilton.

SOCIAL STUDIES
Taylor portrayed beautiful Angela Vickers, here with two beaus. A Place in the Sun won six Academy Awards, including Best Director for George Stevens.

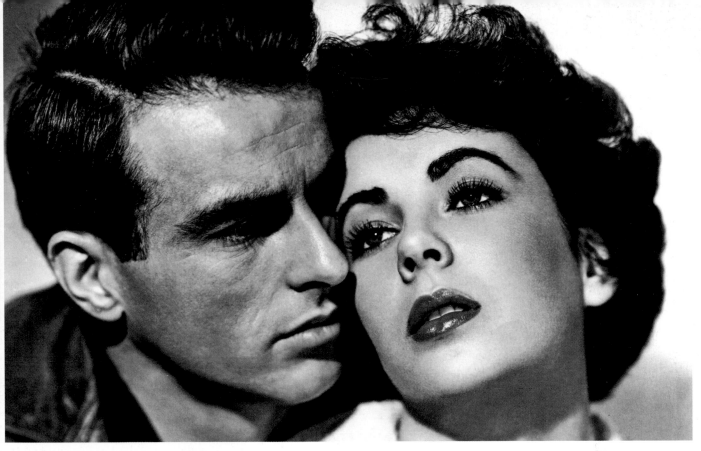

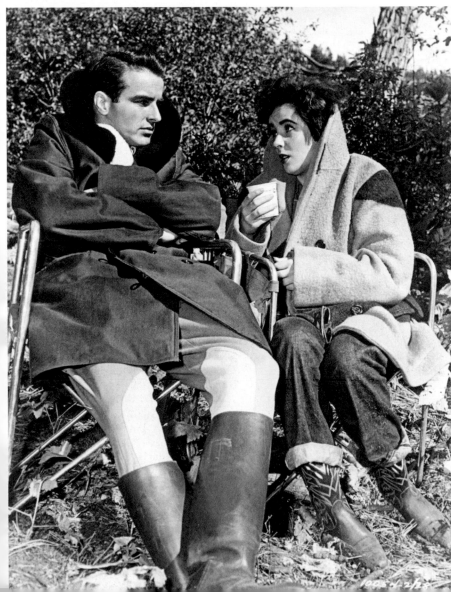

A Place in the Sun

1951

This adaptation of Theodore Dreiser's *An American Tragedy* paired Taylor with Montgomery Clift as lovers—she a pampered debutante, he a social climber trying to cover up his poor background (and his pregnant girlfriend, played by Shelley Winters). Although Clift had affairs with men, his onscreen chemistry with Liz was potent. Taylor didn't diminish an actor's sex appeal but often amplified it.

ABOVE
DOOMED LOVE
"I've loved you since the first moment I saw you," declared up-and-comer George Eastman. Clift's intense performance gave the film its pathos.

LEFT
PLATONIC CHEMISTRY
Taylor loved costar Monty "with all my heart" but "knew he was meant to be with a man."

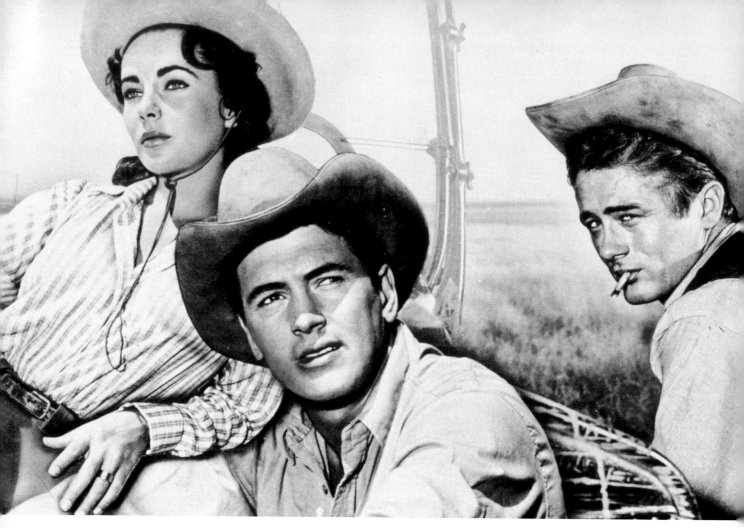

Giant

1956

In this Texas saga, Taylor played Leslie, an eastern lady who marries cattle baron Bick Benedict (Rock Hudson). Under the vast sky, Taylor modulated her performance between matrimonial warmth and casual erotic vibes with Jett Rink (James Dean), a rival oilman. Although *Giant* was nominated for Best Picture, the Oscar went to Mike Todd's *Around the World in 80 Days*.

ABOVE
UNDER THE TEXAS SUN
Taylor, who campaigned for the role of Leslie after Grace Kelly was unavailable, grew close to costars Hudson (center) and Dean during the filming.

RIGHT
NOT A LONE STAR
"We had no secrets from each other, ever, through the years," said Taylor about Hudson.

"I've always admitted that I'm ruled by my passions"
—ELIZABETH TAYLOR

Raintree County

1957

In its big-budget imitation of *Gone with the Wind*, MGM cast Taylor as a wife who drives her husband (Montgomery Clift) into enlisting with the Union Army during the Civil War. Filming was sidetracked for months by Clift's disfiguring 1956 car wreck, which took place after he left a dinner at Taylor's home.

Cat on a Hot Tin Roof

1958

Taylor was at her sexiest in Tennessee Williams's southern family drama, playing a woman running out of patience and tricks in trying to lure her depressed, hard-drinking—and likely homosexual—husband into bed. Maggie craves her husband, Brick, just as much as she lusts after his family money. Taylor's performance is playful but sharp in showing Maggie's growing desperation.

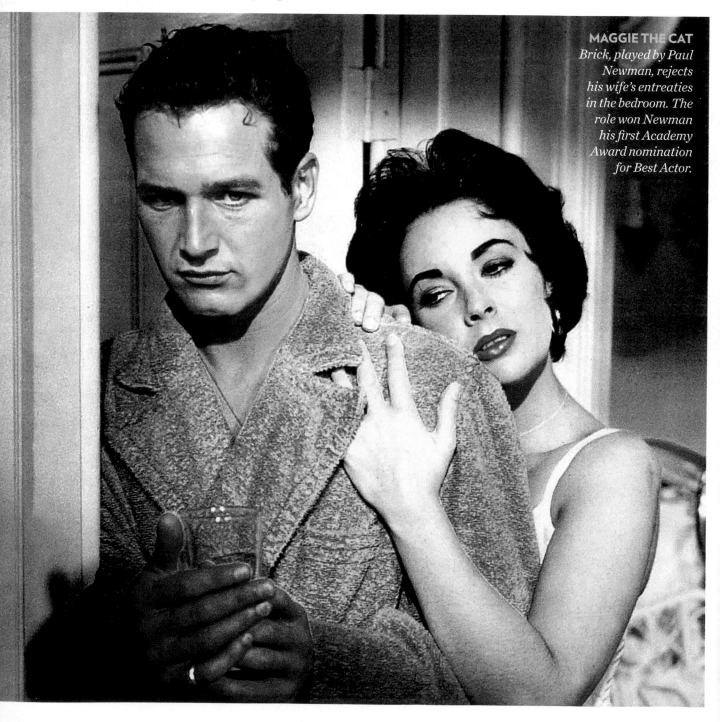

MAGGIE THE CAT
Brick, played by Paul Newman, rejects his wife's entreaties in the bedroom. The role won Newman his first Academy Award nomination for Best Actor.

Suddenly Last Summer

1959

Based on a Tennessee Williams play, the movie's subject matter—homosexuality, cannibalism and mental illness—was groundbreaking for its era. Directed by Joseph L. Mankiewicz, Taylor was cast as a woman traumatized by her cousin's mysterious death; Katharine Hepburn played the wealthy, domineering aunt; Montgomery Clift, hobbled by drug and alcohol use after his near-fatal car accident, played a neurosurgeon.

NO DAY AT THE BEACH
Screenplay cowriter Gore Vidal had to tone down elements of the shocking play. Taylor called the film "the most complex picture I've ever worked on."

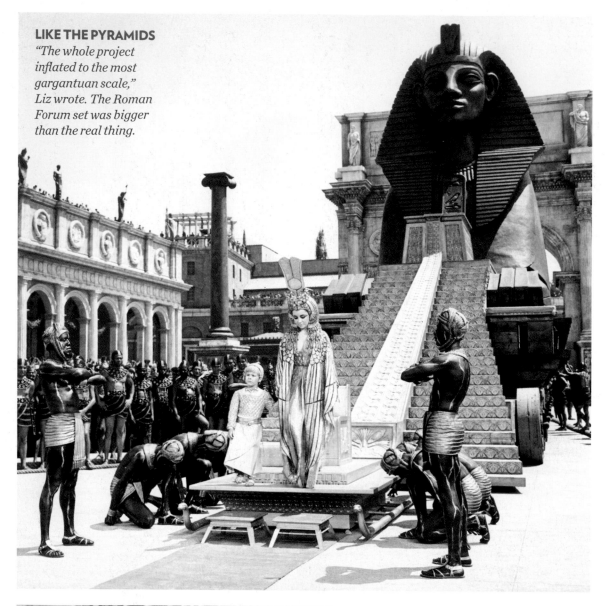

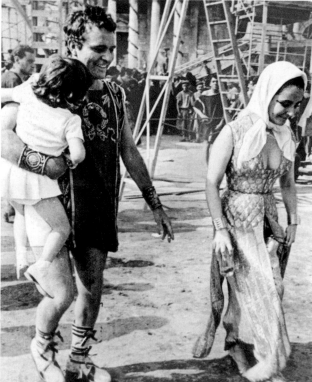

Cleopatra

1963

It was a spectacle all right. The most expensive movie ever made cost roughly $300 million in today's dollars and almost shuttered 20th Century Fox. Production spanned about three years. Taylor nearly died from pneumonia and had to have a tracheotomy. Liz and Dick were unleashed upon the world. And reviews were bad.

PRENUP BOOST
Burton, soon to be the new daddy, carried Liza Todd in 1962.

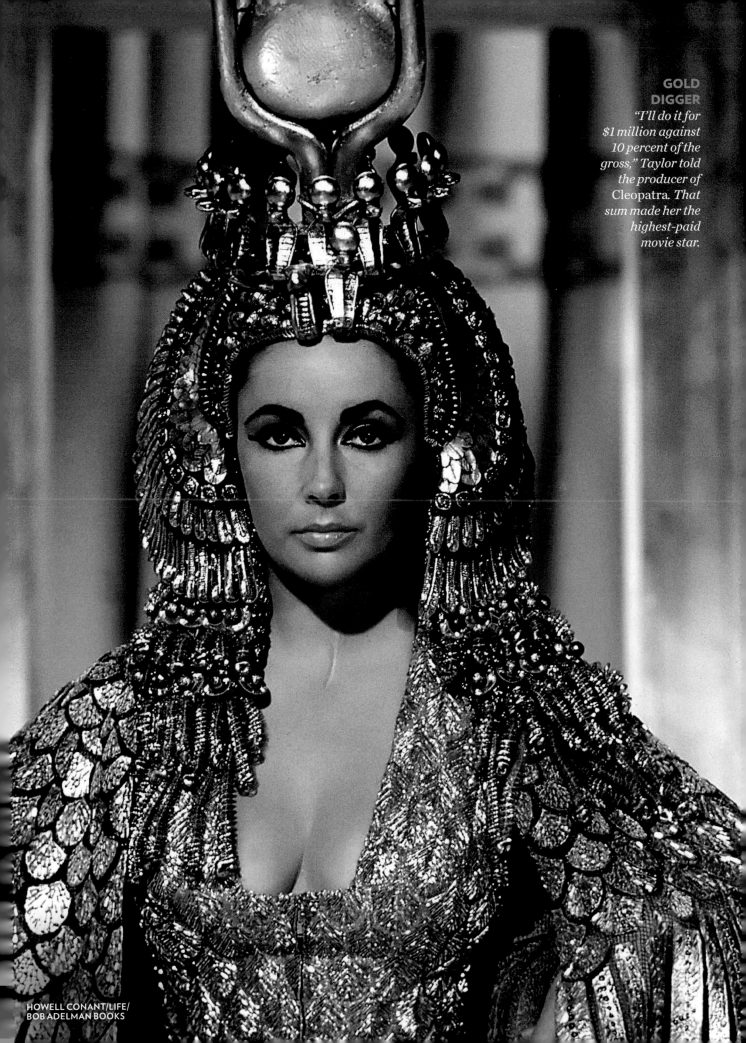

GOLD DIGGER
"I'll do it for $1 million against 10 percent of the gross," Taylor told the producer of Cleopatra. That sum made her the highest-paid movie star.

OSCAR GLORY

She wasn't just a movie star. Elizabeth Taylor was nominated three times for Best Actress (for *Raintree County, Cat on a Hot Tin Roof* and *Suddenly Last Summer*) before taking home an Oscar in 1961 for *BUtterfield 8*. She won again in 1967 for *Who's Afraid of Virginia Woolf?* but didn't attend the ceremony because husband Richard Burton, up for Best Actor, thought he'd lose. Her last prize: the Jean Hersholt Humanitarian Award in 1993.

BUtterfield 8

1960

Taylor didn't want to make this movie about an amoral Manhattan call girl who's nonetheless too decent to settle for being a married man's mistress. (Prize line: "Mama, face it—I was the slut of all time.") Still, her performance had all the hallmarks of mature acting style, jumping from carnal sympathy to bitchy humor to little-girl tremulousness. Something in the performance worked.

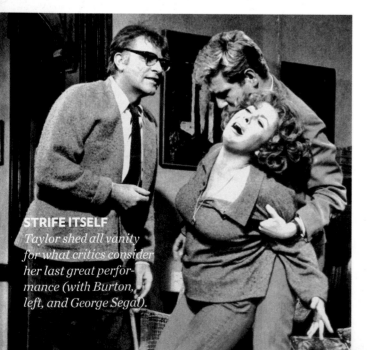

STRIFE ITSELF
Taylor shed all vanity for what critics consider her last great performance (with Burton, left, and George Segal).

Who's Afraid of Virginia Woolf?

1966

Taylor's Oscar-winning performance in this movie version of Edward Albee's play (directed by Mike Nichols) remains one of the meatiest star turns by any American actress. To play Martha, the blowsy, boozy harridan whose marriage to a mousy, boozy history professor conceals a heartbreaking secret, Taylor gained 25 lbs. and crammed a salt-and-pepper wig onto her head. "I've never been so happy doing a film," Liz once wrote. "I did it with all holds unbarred."

SYMPATHY VOTE

Husband Eddie Fisher helped Liz pick up her Best Actress Oscar for BUtterfield 8. That year, she had nearly died from pneumonia, prompting fellow nominee Shirley MacLaine to quip, "I lost to a tracheotomy."

TRANSCONTINENTAL
Grace Kelly, Liz Taylor and Laraine Day flew TWA from L.A. to New York in the early 1950s. Kelly, then the biggest star, had not yet wed Prince Rainier. Day was there to root for the Giants, managed by husband Leo Durocher.

> ❝*I don't pretend to be an ordinary housewife*❞
> —ELIZABETH TAYLOR

THE JET-SETTER

From the slopes of Gstaad to the deck of her yacht, Liz circled the globe in grand style—and settled in some of the world's most glamorous places

LOVE BOAT
Liz's yacht the Kalizma *(named for daughters Kate, Liza and Maria) was furnished with Chippendale mirrors and English tapestries.*

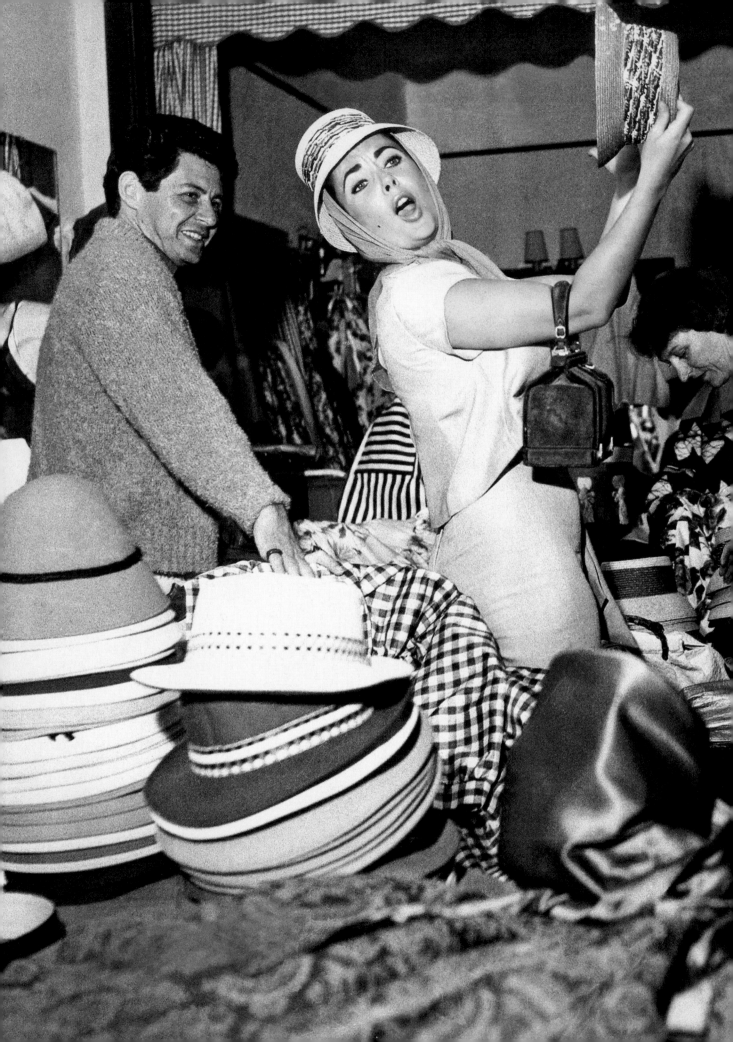

Cannes
France

Although she never won an award, Liz was a fixture at the glamorous Cannes International Film Festival—and in the Riviera city known for its grand hotels and luxurious yachts. Starting in the 1990s, Liz raised millions for AIDS research by holding star-studded benefits at the film festival.

By the time Elizabeth Taylor was 30, her tumultuous life and over-the-top lifestyle had upstaged her acting. "Everything was handed to me," she told LIFE magazine in 1992. "Looks, fame, wealth, honors, love. I rarely had to fight for anything."

She may not have had to fight, but she brought great exuberance to living large. A big spender, she would shop till she (or her staff) dropped. Her epic life was accompanied by epic consumption: of fantastic jewels, a herd of furs, homes around the globe, a fleet of Rolls-Royces, luxurious yachts and private planes. No whim was too outrageous. When she and Richard Burton arrived in London for a film shoot in 1968, they chartered a 200-ton yacht and docked it in the Thames near the Tower of London to kennel her pets at a cost of $21,600. Such a sum was a pittance to the pair, whose combined earnings reached nearly $90 million in the 1960s.

Taylor's love of luxe lasted her entire life. Her Bel Air mansion contained masterworks by Rembrandt and van Gogh, and her jewelry vault must have rivaled Fort Knox. Giving and receiving gifts was one of her greatest pleasures. "I am glad that I knew the wildness, glamour and excitement when I was in my prime," she told PEOPLE in 1996. "The parties, the yachts and the private jets and the jewelry—the whole thing was so exciting. It was a great time to be young, alive and attractive."

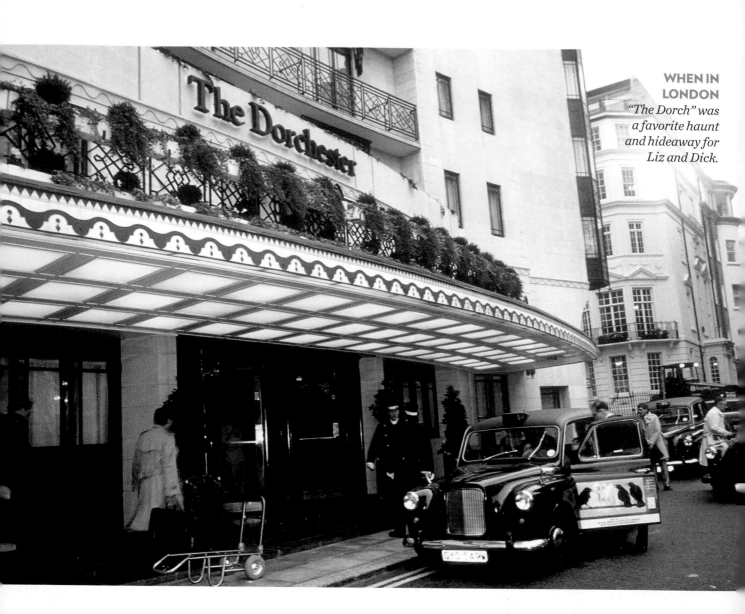

WHEN IN
LONDON
*"The Dorch" was
a favorite haunt
and hideaway for
Liz and Dick.*

London
England

Although Liz was born
in England, she did
not own a home there.
When in London, the
Burtons would stay
at the Dorchester,
where they imbibed
prodigiously in the
lobby bar, then slept it
off in their penthouse
roof-garden apartment.

LIKE AN ARMY ON THE MARCH *Liz routinely traveled with a baggage train, as well as a
secretary, a maid and often two dogs and a cat. She left the horses at home.*

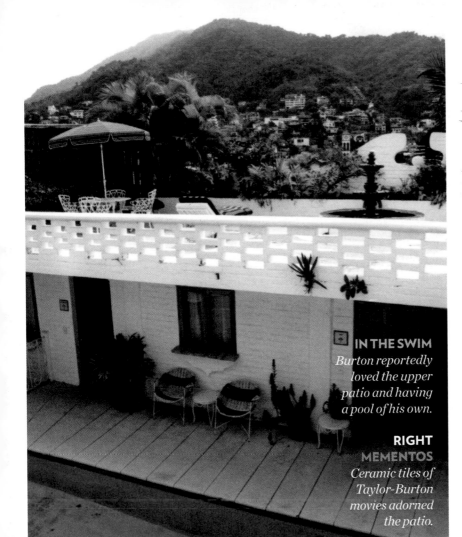

Puerto Vallarta
Mexico

When Richard Burton filmed *The Night of the Iguana* at Puerto Vallarta's Playa Mismaloya, the couple were taken with the town, nestled in the foothills of the Sierra Madre mountain range. So they bought a 20-room retreat, which they dubbed Casa Kimberley.

IN THE SWIM
Burton reportedly loved the upper patio and having a pool of his own.

RIGHT
MEMENTOS
Ceramic tiles of Taylor-Burton movies adorned the patio.

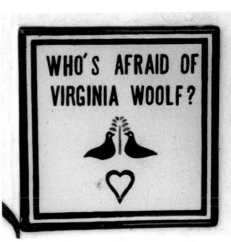

TAKE THE TOUR
A retired couple bought Casa Kimberley in the early '90s, maintained the decor and conducted daily tours.

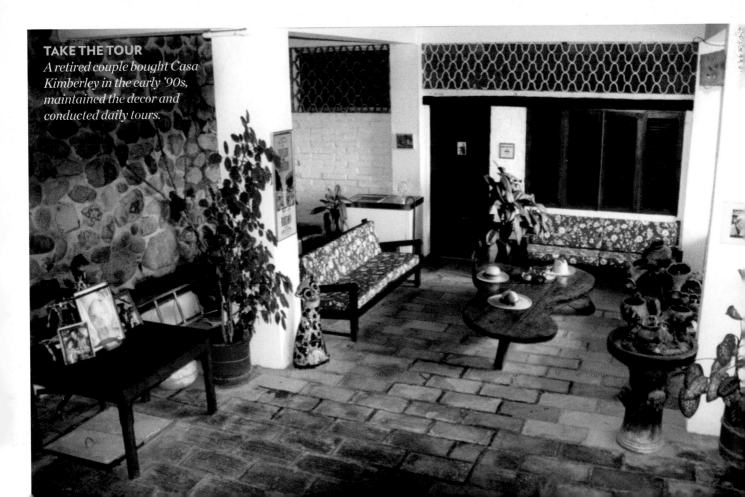

Bel Air
United States

Elizabeth Taylor spent the last years of her life in Los Angeles, living in Bel Air, home to the rich and famous. Her sprawling house, bought in 1981, had art by Degas and Renoir hanging from the walls and three gold statuettes named Oscar on the mantel.

MUST LOVE DOGS
Inseparable from her favorite pooches, Liz rub-a-dubbed with her furry fan club nearby.

Gstaad
Switzerland

This exclusive resort was a magnet for the jet set, who loved its shopping, skiing and nightlife. TIME called it The Place in the 1960s; in 1963, *The Pink Panther,* starring Peter Sellers and David Niven, was filmed there. Among the celebrities who flocked to Gstaad: Princesses Grace and Diana, Michael Jackson and, of course, Liz and Dick.

IN FROM THE COLD
After Cleopatra, *Taylor retreated to Gstaad. "It was the only home I had—my children were going to school there."*

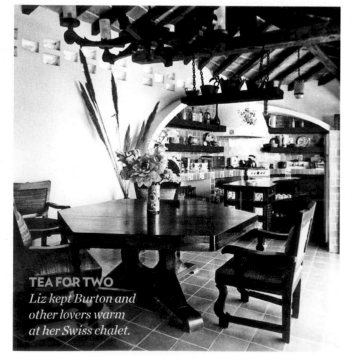

TEA FOR TWO
Liz kept Burton and other lovers warm at her Swiss chalet.

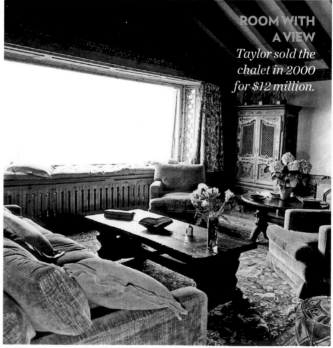

ROOM WITH A VIEW
Taylor sold the chalet in 2000 for $12 million.

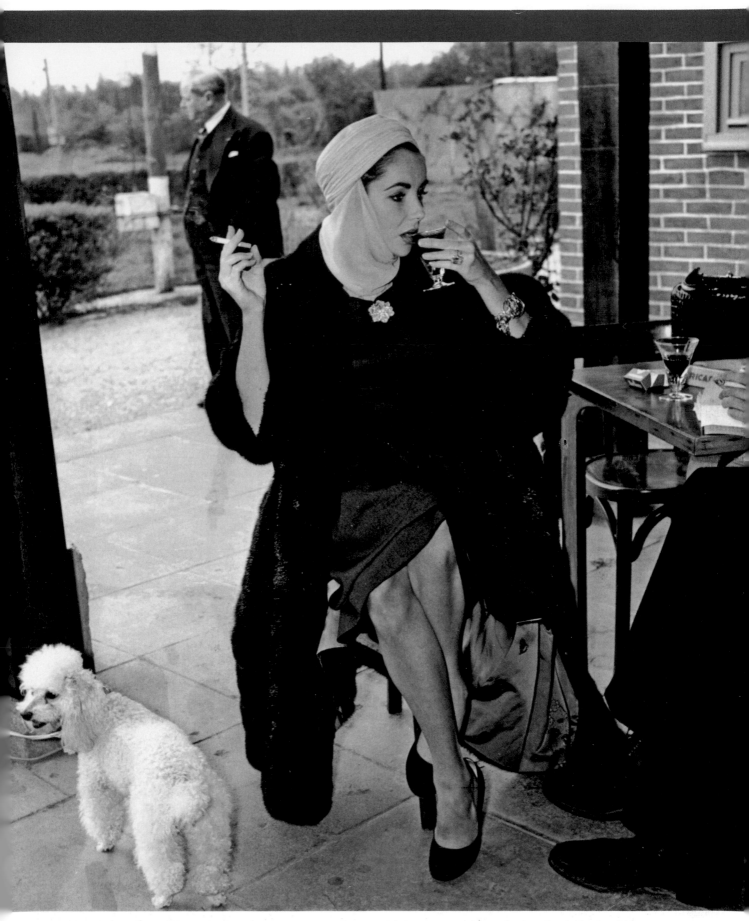

TRAVELING'S A DRAG *Dog in tow, Taylor sipped a drink at Jersey airport in the Channel Islands en route to Nice in 1957. She was fortifying herself before interviews with the press.*

HIGH SOCIETY

Taylor's high drama and celluloid glamour captivated the world. She was honored by the French government and denounced by the Vatican. And that other Queen Elizabeth made the silver screen queen a Dame Commander of the Order of the British Empire in 1999.

LIZ AND DICK
Nixon and Taylor attended the 1990 funeral of mutual friend Malcolm Forbes.

TWO ELIZABETHS
Taylor and the Queen Mum (left) at a 1968 wedding at Fairlawn, Sussex.

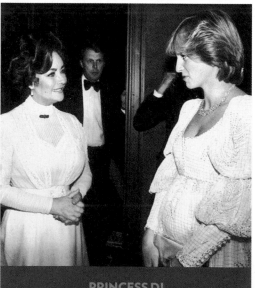

PRINCESS DI
Taylor chatted with the pregnant princess in 1982 after her performance in The Little Foxes at London's Victoria Palace Theatre.

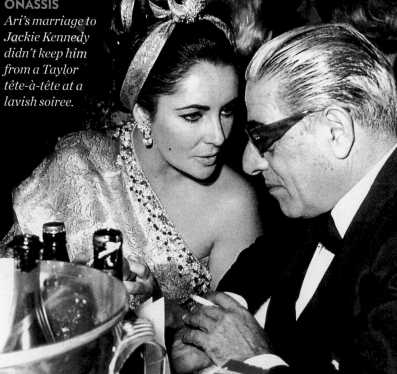

ONASSIS
Ari's marriage to Jackie Kennedy didn't keep him from a Taylor tête-à-tête at a lavish soiree.

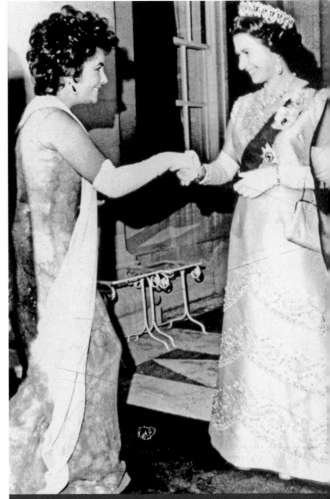

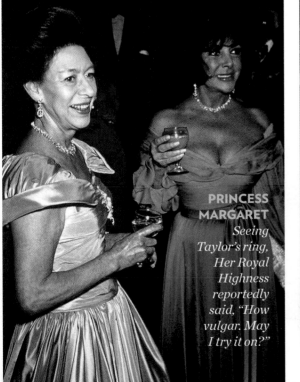

PRINCESS MARGARET
Seeing Taylor's ring, Her Royal Highness reportedly said, "How vulgar. May I try it on?"

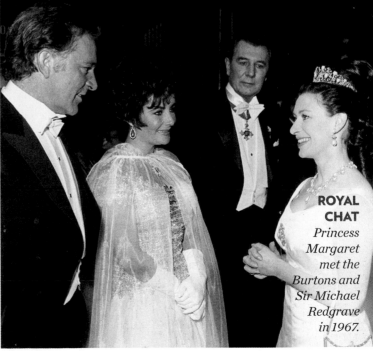

ROYAL CHAT
Princess Margaret met the Burtons and Sir Michael Redgrave in 1967.

A GIRL'S BEST FRIEND

Yes, she collected men. But Taylor also loved to acquire jewelry—and show off the treasures of one of the world's great private vaults

ROCK OF AGES

Burton paid $1.1 million in 1969 for the 69.42-carat Cartier diamond, quickly renamed the Taylor-Burton diamond. Elizabeth wore it as a ring (above), but "even for me it was too big," so Cartier designed a necklace to display it (right).

A big girl needs a big diamond," Elizabeth Taylor once said. Of course, sometimes the gems were rubies, like the Cartier necklace Mike Todd wrapped around her while she swam in a Monte Carlo pool. Or emeralds, notably the Bulgari piece Richard Burton bought her in Rome. But, oh, those diamonds! After Burton purchased the 33.19-carat Asscher-cut Krupp diamond in 1968, Liz said, "It hums with its own beatific life," and wore it on her finger. The following year Burton paid $1.1 million for the giant Cartier diamond. This rock, quickly dubbed the Taylor-Burton diamond, was so big it had to be hung from a necklace. Vulgar? Perhaps. But Taylor researched her acquisitions like a curator and documented her expertise in *Elizabeth Taylor: My Love Affair with Jewelry.* "I've never thought of my jewelry as trophies," she wrote. "I'm here to take care of them and to love them."

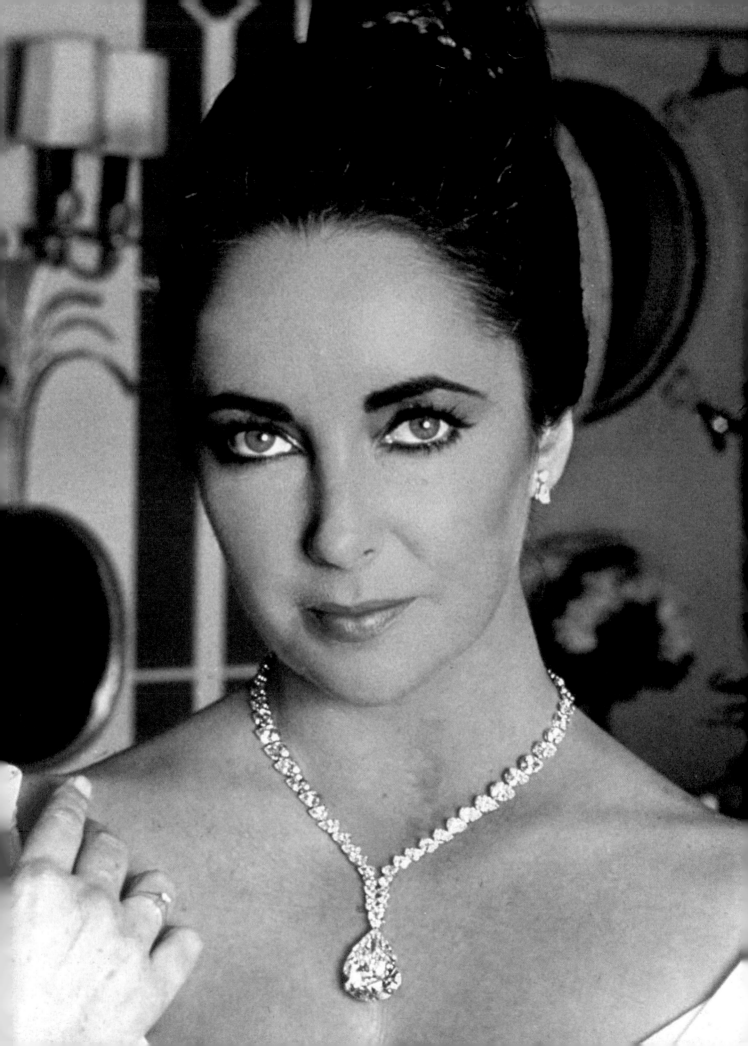

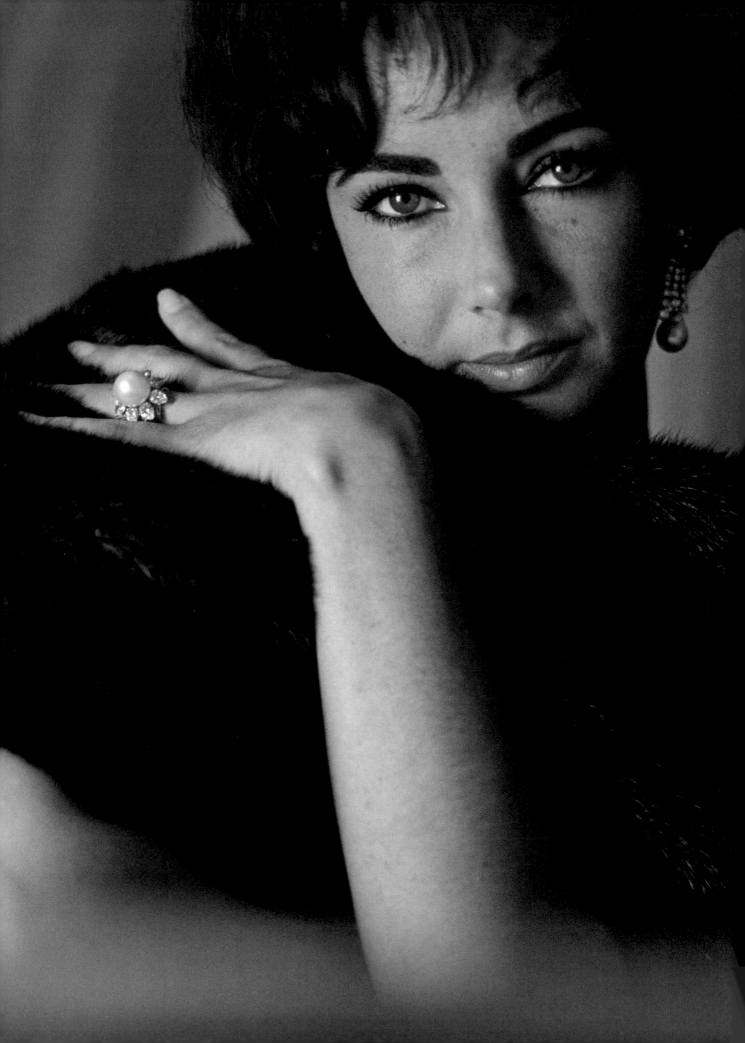

> ❝*As I look at my jewels,*
> *I realize what a lucky girl I am* ❞
> **—ELIZABETH TAYLOR**

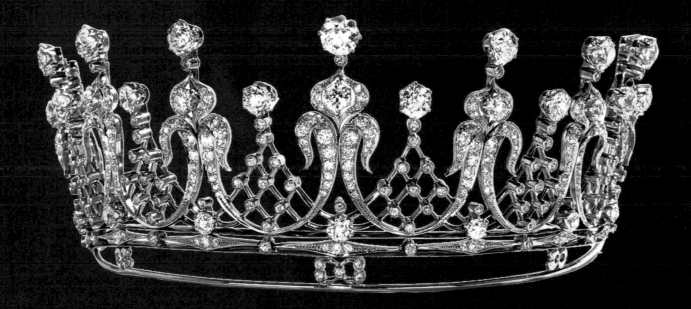

FIT FOR A QUEEN
*Mike Todd crowned
Taylor with this circa 1880
diamond tiara in 1957.
She wore it to the Oscars
later that year.*

OPPOSITE
YOUNG LOVE
*The pearl at the center
of Taylor's ring was a present
from her uncle Howard
Young. The South Sea–pearl-
and-diamond ear pendants
"started my love of long, drippy
earrings," she wrote.*

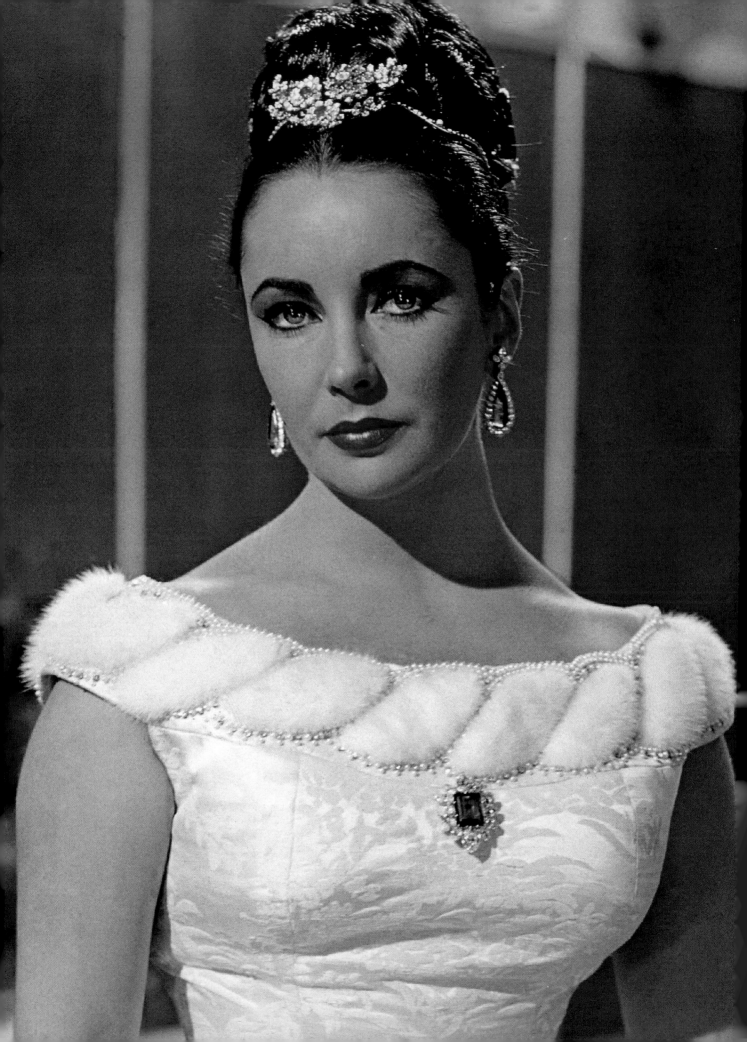

> ## "I thought, 'Oh my God! I've got to have the emeralds'"
> —ELIZABETH TAYLOR

BUT SHE'S WORTH IT
*Burton said arrivederci to his $100,000
spending limit once Taylor saw this
Bulgari creation during a Rome shopping trip.*

OPPOSITE
EMERALD CITY
*The necklace could be worn as a tiara, the pendant
as a brooch; Burton added matching earrings
as a 32nd-birthday present to make the set complete.*

LEFT
NO CONTEST
Sammy Davis Jr. attended the 1974 premiere of That's Entertainment resplendent in beads and gold. He was no match, though, for La Liz, who came dripping with diamonds.

BELOW
ROYAL INSIGNIA
Taylor purchased the Prince of Wales brooch from the estate of her friend the Duchess of Windsor. Liz felt "she wanted me to have it."

OPPOSITE
WHAT HAVE I DONE?
Hard to tell if Burton is more astonished by Liz's beauty—or by the millions of dollars she's wearing.

> 66 *I introduced Elizabeth to beer. She introduced me to Bulgari* 99
> —RICHARD BURTON

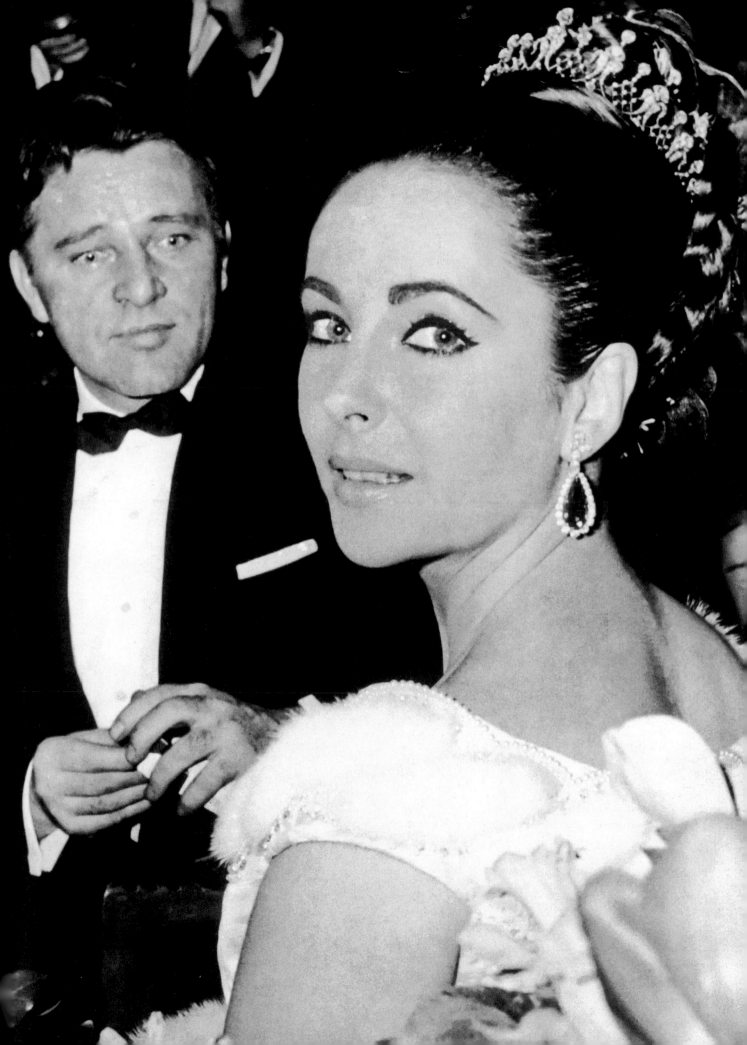

"*You can't possess radiance, you can only admire it*"
—ELIZABETH TAYLOR

CHARMED LIFE
Mike Todd wrapped this ruby-and-diamond Cartier piece around his wife's neck in the pool of their rented Monte Carlo villa in 1957.

OPPOSITE
LADY IN RED
Taylor loved wearing Mike Todd's ruby-and-diamond necklace because "it was like the sun, lit up and made of red fire."

THE TAJ WAS TOO BIG
*Burton's 40th-birthday gift was
the Taj Mahal diamond
on a chain made in 1627 for the
wife of a Mughal emperor.*

OPPOSITE
GIRL WITH A PEARL
*Richard Burton acquired
La Peregrina pearl, which
had been a wedding present
from Prince Philip II of
Spain to his wife, Mary Tudor.
Later, the Burtons commissioned
a new setting of pearls,
diamonds and rubies based
on a necklace worn by Mary,
Queen of Scots.*

66 *This kind of
beauty is so rare* 99
—ELIZABETH TAYLOR

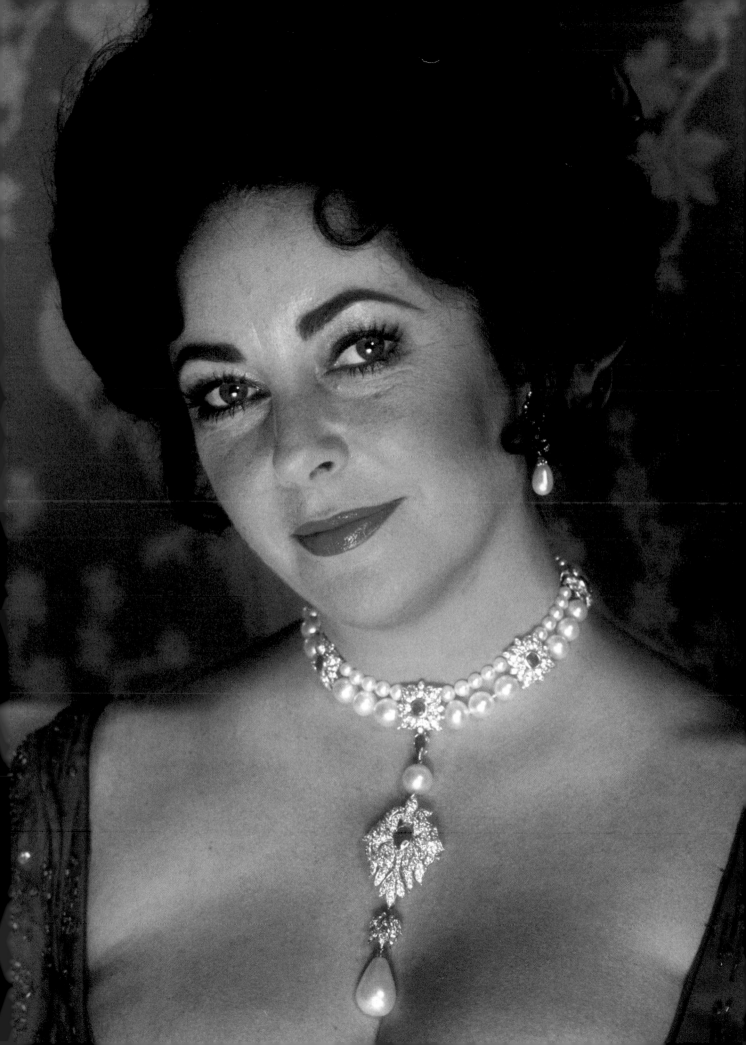

SOUL MATES

Even though she had a revolving door of husbands,
Liz made a lifetime's worth of friends—from Rock Hudson
to Michael Jackson—who were there for the long haul

RIGHT
SEX SYMBOLS
"Rock and I hit it off right away," Taylor
said. *After a day's shooting on* Giant, *they would
bond at night over chocolate martinis.*

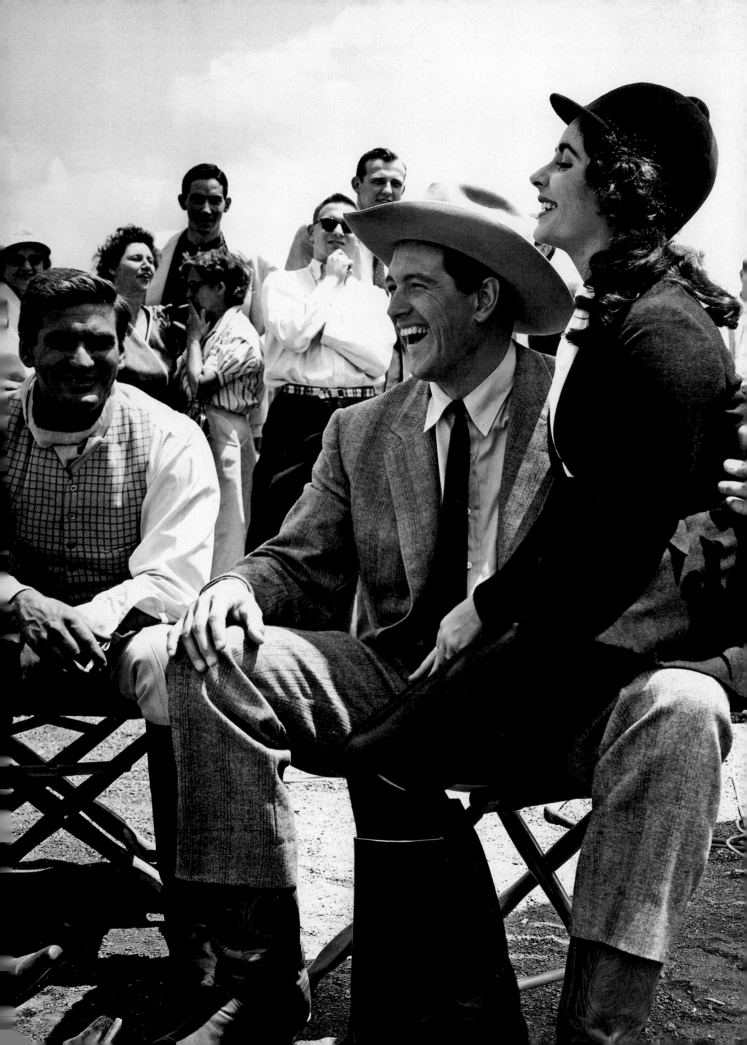

Taylor's leading men were able to give her something no husband ever did: lifetime loyalty. She met her closest friend, Roddy McDowall, when she was 10; Mickey Rooney when she was 12. Robert Stack, who played Taylor's love interest in *A Date with Judy* when he was 29 and she was 16, praised her in 1989: "You're a star at an age when you should be in school. It's all tinsel and moonlight. And the fact that any of them survive it at all is remarkable. I take my hat off to Elizabeth."

Oddly enough, many of Taylor's close male friends were gay. "Take out the homosexuals and there's no Hollywood!" said Liz on Whoopi Goldberg's talk show in 1992. Indeed, Taylor held great tenderness for Montgomery Clift and Rock Hudson. One friend thought her attraction to gay men may have stemmed from seeing them as "a challenge to be met." But Taylor also had many women friends, including, surprisingly, Debbie Reynolds. Reynolds once said, referring to ex-husband Fisher, "In the long run, Elizabeth did me a big favor."

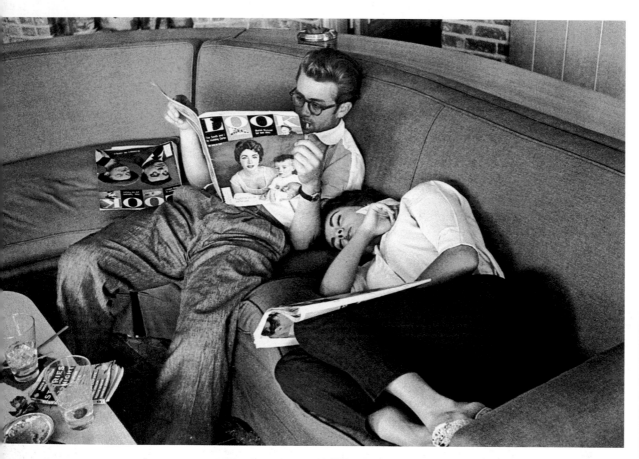

ABOVE
COVER GIRL
James Dean studied up on Liz while his Giant costar took a snooze.

RIGHT
NO BUSINESS LIKE SHOW BUSINESS
Taylor and Clift congratulated Judy Garland after her performance at the Palace in New York.

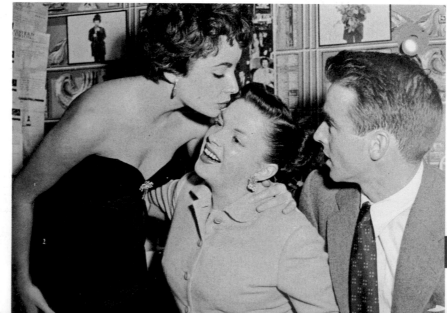

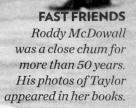

FAST FRIENDS
Roddy McDowall was a close chum for more than 50 years. His photos of Taylor appeared in her books.

STILL INVOLVED
Richard Burton's fourth wife, Sally Hay, eyed Liz (with Victor Luna) when the exes starred in Private Lives.

FIT LIKE A GLOVE
Taylor and Michael Jackson were both young stars. Said Liz: "Neither one of us ever had a childhood."

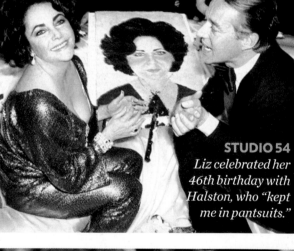

STUDIO 54
Liz celebrated her 46th birthday with Halston, who "kept me in pantsuits."

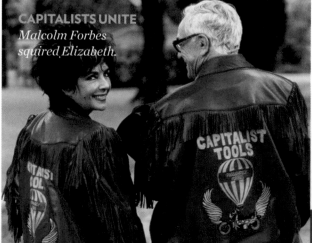

CAPITALISTS UNITE
Malcolm Forbes squired Elizabeth.

> **"I crawled into the car and lifted him away from the steering wheel"**
>
> —**ELIZABETH TAYLOR** on being first at the scene of Clift's accident

TWISTER
Taylor adored costar Clift. Burton once told him, "Elizabeth likes me, but she loves you."

❝*I believe in life, and I'll fight for it* ❞
—ELIZABETH TAYLOR

THE SURVIVOR

Who holds the world's record
for medical emergencies?
No one knows, but guess who a
leading contender would be

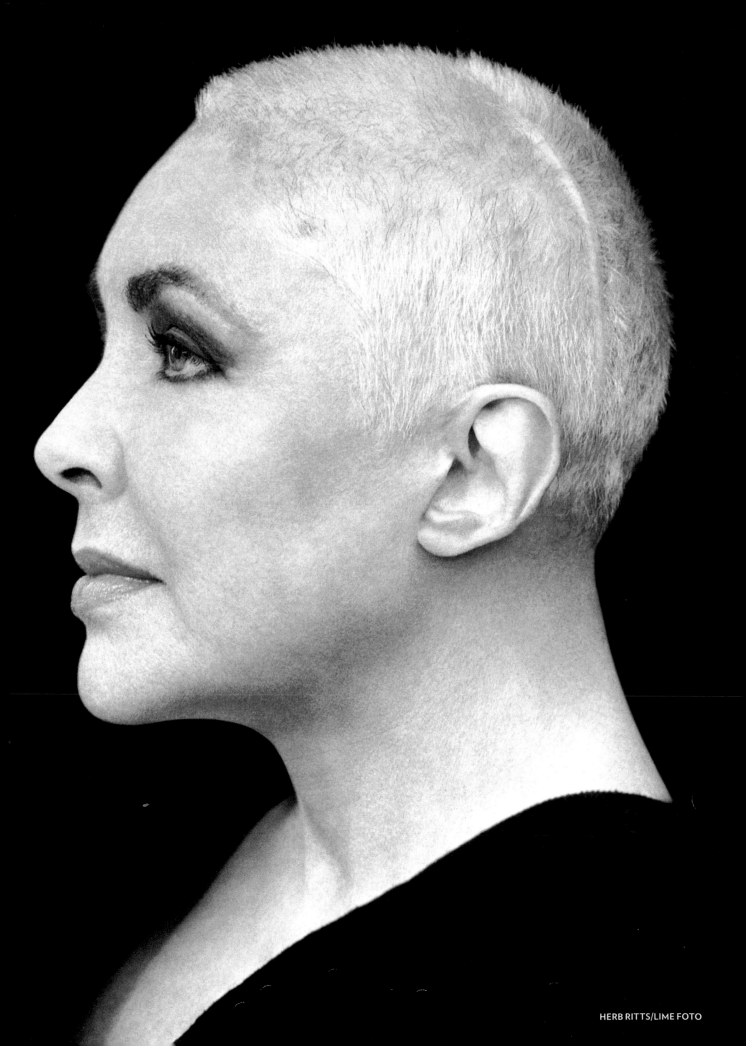

As a major child star whose mother insisted that her daughter's contracts include an "Irene Dunne" clause—named for the actress who refused to work during her menstrual period—Taylor learned early on that she had one weapon she could wield in battles with imperious studio bosses: her health. Knowing that a simple head cold could shut down production, Liz would work her will simply by threatening to call in sick.

Of course, many of her hospital visits were motivated by necessity rather than spite. Thrown by her horse while shooting *National Velvet* in 1944, Liz suffered, at 12, the first of many back injuries. But as she grew older, emotional crises often coincided with health problems. In February 1951, she collapsed on the stand during her Nicky Hilton divorce trial and checked herself into Los Angeles's Cedars-Sinai Medical Center for nervous exhaustion, ulcers and colitis. Eventually Taylor would make almost as many headlines for her hospitalizations as for her husbands.

After she turned 60, the ailments got ever more serious. "A wheelchair is my worst nightmare," she declared in 1998 as she was wheeled from the hospital. "It makes me feel like such an invalid." She entered Cedars-Sinai so often that she reportedly spent $100,000 redecorating her favorite suite. In a rare interview about her health in 2002, Liz said, "I've been pronounced dead, not able to breathe, and I went to the tunnel with the white light." By 2004, when it was reported that she suffered from congestive heart failure, Liz admitted, "I feel so stupid and feeble."

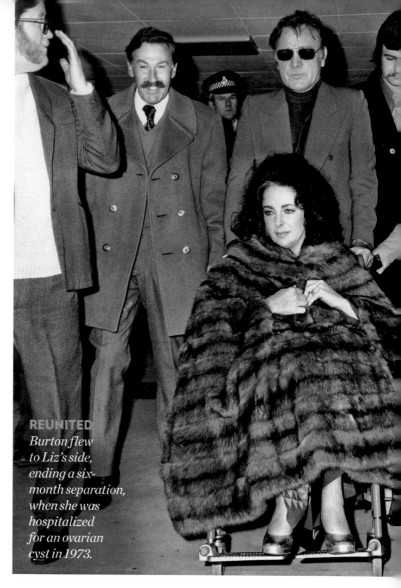

REUNITED
Burton flew to Liz's side, ending a six-month separation, when she was hospitalized for an ovarian cyst in 1973.

MORE LIVES THAN A CAT
Five decades of a crisis-prone life

OCTOBER 1955
Furious when she was ordered back to work on *Giant* right after James Dean's death, a distraught Liz was hospitalized for intestinal ills and bronchitis.

NOVEMBER– JANUARY 1956
Liz fell aboard a yacht while vacationing with Mike Todd and spent two months at New York's Columbia-Presbyterian Hospital for three crushed spinal discs.

DECEMBER 1957
After spending a week in an adjoining hospital room while Liz recovered from an appendectomy, Mike Todd groused to reporters, "No more hospitals."

MARCH 1958
Bedridden with pneumonia and a 102-degree fever, Liz was forbidden by her doctor to accompany Todd on his fatal cross-country plane trip.

NOVEMBER 1960
With her marriage to Eddie Fisher crumbling, the *Cleopatra* production starting and Liz strung out on painkillers and alcohol, she was admitted to Britain's London Clinic, where the diagnosis was meningitis.

MARCH 1961
About to resume production on *Cleopatra*, Liz was hospitalized with double pneumonia and respiratory failure. When doctors performed a tracheotomy and put her on a respirator, word was telegraphed around the world that she might not make it.

FEBRUARY 1962
Taylor reportedly overdosed on Seconal when Burton returned to his wife, Sybil. Liz's stomach was pumped at the Salvator Mundi International Hospital in Rome. The spin: She ate bad oysters.

JULY 1968
Bingeing on pain pills, Liz began hemorrhaging and underwent a partial hysterectomy in London.

NOVEMBER 1973
Doctors performed surgery to remove an ovarian cyst they feared might be malignant. It was benign.

OCTOBER 1978
While campaigning with husband John Warner in Big Stone Gap, Va., Liz suffered a lacerated esophagus when she famously choked on a chicken bone.

JANUARY 1983
Following an auto accident in Israel, Liz had surgery to repair ruptured ligaments in her legs.

DECEMBER 1983
After an intervention for alcohol and pills by her family and old friend Roddy McDowall, Liz entered the Betty Ford Center in Rancho Mirage, Calif., for rehab.

OCTOBER–DECEMBER 1988
Addicted to painkillers she was taking to relieve chronic back pain, Liz returned to the Betty Ford Center, where she met fellow patient Larry Fortensky.

APRIL 1990
Liz entered St. John's Hospital Health Center in Santa Monica for treatment of a pulmonary virus.

MAY 1990
She told a friend, "I'm dying," but survived after her chest was opened surgically and catheters inserted.

SEPTEMBER 1991
Treated at Methodist Hospital in Houston after a dizzy spell, Liz postponed her wedding to Fortensky.

MARCH 1994
Hip replacement surgery left one leg shorter than the other. Months of painful physical therapy followed.

JUNE 1995
A second arthritic hip was replaced.

JULY 1995
While Liz was treated at St. John's for an irregular heartbeat, Fortensky partied in her absence—and was subsequently sent packing.

OCTOBER 1995
Taylor had a third hip operation, this one to even the length of her legs.

FEBRUARY 1997
After months of severe headaches and memory loss, Liz suffered a seizure days before her 65th birthday. Doctors at Cedars-Sinai removed a golf-ball-size brain tumor.

JANUARY 1998
A fall brought Liz back to Cedars-Sinai with a broken ankle and fractured ribs.

FEBRUARY 1998
Preparing to celebrate her 66th birthday with family, Liz fell, suffering a "severe compression fracture" of a vertebra, and ended up back at Cedars-Sinai.

AUGUST 1999
Dizzy from painkillers prescribed after oral surgery, Liz fell in her bedroom and again broke her back.

AUGUST 2000
Liz spent six days at Cedars recuperating from pneumonia.

SEPTEMBER 2002
Doctors reported that over the summer, Liz had received radiation to eradicate a curable skin cancer.

OCTOBER 2003
"My body's a real mess," said Liz after surgery to repair seven spinal fractures.

OCTOBER 2004
At 72, Liz had more back surgery to repair two fractured discs.

AUGUST 2008
In a visit described as "precautionary," Liz spent several weeks in the hospital for undisclosed reasons.

NEAR DEATH
At 29, Taylor was rushed to the London Clinic, where she underwent an emergency tracheotomy.

LLA 234

SECOND ACT

With fewer film roles to tempt her, Taylor turned her entrepreneurial talent to creating fragrances—notably Passion and White Diamonds—that kept the coffers full

COLOR OF MONEY
*"I'm happier than I
have ever been,"
said Liz (in a 1985
Helmut Newton
portrait that was
used to advertise her
Passion perfume).*

Elizabeth Taylor

Hers wasn't the first celebrity fragrance, but when Elizabeth Taylor's Passion launched in 1987, the business-savvy star single-handedly revolutionized what would become a booming market for star scents. In 1991 she launched her most successful fragrance, White Diamonds, which would go on to gross more than $1 billion worldwide. And she didn't stop there: Her line ultimately spawned 12 scents for which she earned more money than from her entire film career.

A hands-on businesswoman, she personally helped to mix Passion's blend of 200 ingredients, including her favorite flower, gardenia. The project "appealed to the alchemist in me," she told *The Washington Post* in 1987. "I wanted something I could get involved in creatively." She even helped design the bottle: "I got out my pencil and sketched the bottle top."

But her wildly popular perfumes were just part of Taylor's entrepreneurial journey: From 2004 to 2008 she created pieces for House of Taylor Jewelry, which was inspired by her famed passion for baubles. "I'd been doing it all along," she told PEOPLE in 2006, "suggesting to jewelers that I wanted this, that and the other. My manager said, 'Why don't you do it for real?'"

Of her various business ventures, she said, "Money to me is fun. But it is only fun when it is not a burden. I love to give money away. To me that is the whole point of having money: buying gifts. I love to give gifts more than I love to receive them—and I love to receive them."

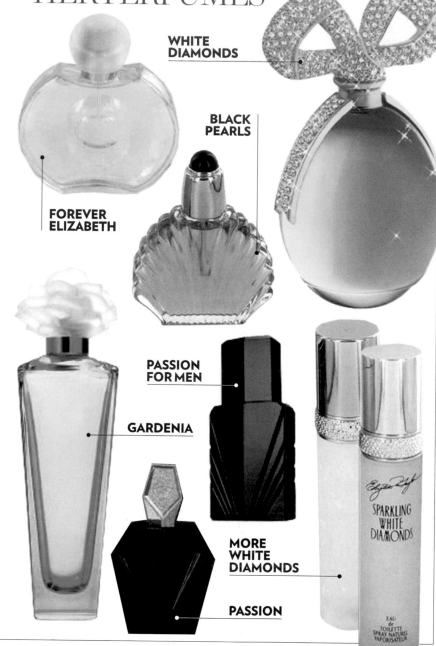

HER PERFUMES

WHITE DIAMONDS

BLACK PEARLS

FOREVER ELIZABETH

PASSION FOR MEN

GARDENIA

MORE WHITE DIAMONDS

PASSION

SPARKLING WHITE DIAMONDS

EAU de TOILETTE SPRAY NATUREL VAPORISATEUR

SWEET SMELL OF SUCCESS

$10 million
The promotional budget for the 1987 launch of Elizabeth Taylor's Passion line of sprays, lotions and dusting powders

$165 an ounce
Cost of Passion at launch

$1 billion plus
Sales for White Diamonds, one of the most successful celeb fragrances of all time

12 scents
Number of fragrances in the House of Taylor Fragrances line

1 men's cologne
Called, not surprisingly, Passion for Men

100,000 plus
Size of the crowd that greeted Taylor during a promotional visit to Taiwan

SHOWBIZ TO EAUBIZ
Taylor launched her new White Diamonds perfume line at an L.A. store in 1991.

WHITE DIAMONDS

ELIZABETH TAYLOR

The fragrance dreams are made of.

"*I am going to get at this disease and kill it by its throat*"

—ELIZABETH TAYLOR

AIDS CRUSADER

After her movie career ended, Taylor put her passion and prestige into fighting a disease that had killed a number of friends. Through relentless campaigning, she raised millions to find a cure

OPPOSITE
MS. TAYLOR GOES TO WASHINGTON

In her campaign against AIDS, Taylor appeared before a Senate subcommittee in 1986 to plead for more research money.

123

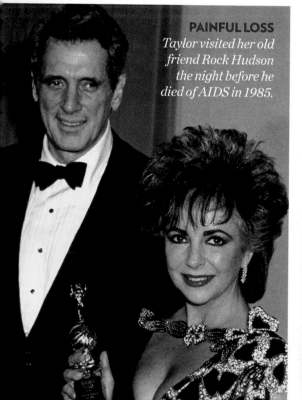

PAINFUL LOSS
Taylor visited her old
friend Rock Hudson
the night before he
died of AIDS in 1985.

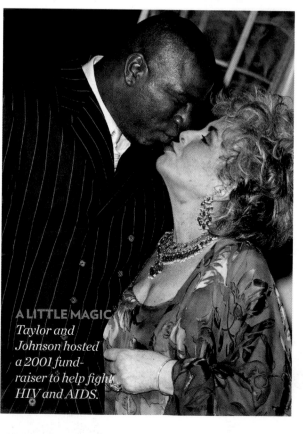

A LITTLE MAGIC
Taylor and
Johnson hosted
a 2001 fund-
raiser to help fight
HIV and AIDS.

WE
IF ONE O

KNOW, P

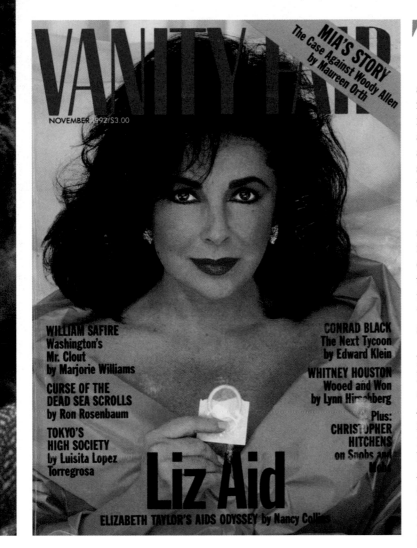

Taylor was asked to host the first AIDS fund-raising dinner ever in 1984. To her dismay, she ran into "seven months of absolute and abject rejection" before finding supporters, she told PEOPLE in 1990. "I thought, 'This is unbelievable what is going on. People aren't aware of the problem because of the stigma,'" she recalled. "It's bad enough to die of a disease, but terrible to die of ignorance."

In the years to come she would lose some of her closest friends—including actor Rock Hudson and fashion designer Halston—to the disease, which only strengthened her resolve to fight it. After Hudson became sick, "I learned more about the disease," she said. "And that just made me angry."

Putting her anger into action, she began traveling the world visiting hospitals. Taylor raised funds for amfAR (American Foundation for AIDS Research), which to date has raised $465 million for research. In 1989 she testified before Congress on behalf of a bill to provide emergency AIDS care in areas hardest hit by the epidemic. And she started her own Elizabeth Taylor AIDS Foundation in 1991 to provide support services for people with the disease. Still, she remained self-deprecating about her good works. "It sounds like I'm out there with a little white uniform on," she said with a laugh in 1990. "I've got to polish my halo off!"

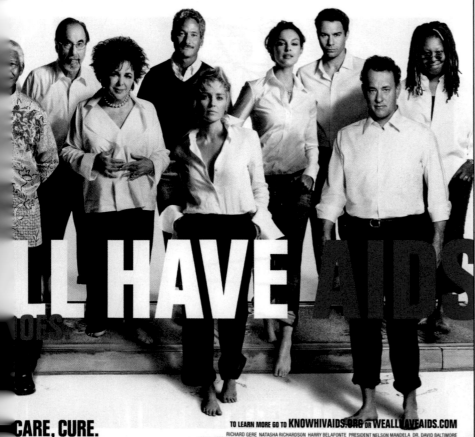

ABOVE

A NEW KIND OF HEADLINE
Taylor won worldwide kudos for her AIDS work.

LEFT

CAUSE CELEBRE
An AIDS awareness ad with (left to right) Richard Gere, Natasha Richardson, Harry Belafonte, Nelson Mandela, Dr. David Baltimore, Taylor, Greg Louganis, Sharon Stone, Ashley Judd, Eric McCormack, Tom Hanks and Whoopi Goldberg.

Editors Ellie McGrath, Richard Sanders, Jess Cagle **Design Director** Andrea Dunham, Sara Williams **Director of Photography** Chris Dougherty **Art Directors** Jason Arbuckle, Cass Spencer **Designers** Eulie Lee, Cynthia Rhett **Photography Editor** Brenna Britton **Assistant Photography Editors** Maxine Arthur, James Miller, Christine Ramage, Sabine Rogers **Writers** Tom Gliatto, Chris Strauss, Michelle Tauber **Reporters** Deirdre Gallagher, Irene Neves **Copy Chief** Ben Harte **Production Artists** Georgine Panko (Art Production Director), Denise M. Doran, Cynthia Miele **Scanners** Brien Foy, Stephen Parabue **Imaging** Francis Fitzgerald (Director), Robert Roszkowski (Manager), Romeo Cifelli, Paul Dovell, Charles Guardino, Jeff Ingledue **Special Thanks To** Robert Britton, David Barbee, Jane Bealer, Sal Covarrúbias, Margery Frohlinger, Suzy Im, Ean Sheehy, Céline Wojtala, Patrick Yang

TIME HOME ENTERTAINMENT Publisher Richard Fraiman **General Manager** Steven Sandonato **Executive Director Marketing Services** Carol Pittard **Executive Director Retail & Special Sales** Tom Mifsud **Executive Director New Product Development** Peter Harper **Director Bookazine Development & Marketing** Laura Adam **Publishing Director** Joy Butts **Assistant General Counsel** Helen Wan **Book Production Manager** Suzanne Janso **Design & Prepress Manager** Anne-Michelle Gallero **Brand Manager** Michaela Wilde **Associate Brand Manager** Melissa Joy Kong **Special Thanks To** Christine Austin, Jeremy Biloon, Glenn Buonocore, Malati Chavali, Jim Childs, Susan Chodakiewicz, Rose Cirrincione, Jacqueline Fitzgerald, Carrie Frazier Hertan, Christine Font, Lauren Hall, Malena Jones, Mona Li, Robert Marasco, Kimberly Marshall, Amy Migliaccio, Nina Mistry, Dave Rozelle, Ilene Schreider, Adriana Tierno, Alex Voznesenskiy, Jonathan White, Vanessa Wu

FRONT COVER

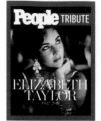

John Bryson/Time & Life Pictures/Getty Images

TABLE OF CONTENTS

2-3: Sharok Hatami/Rex USA **4-5:** Bob Landry/Time & Life Pictures/Getty Images

A LEGENDARY LIFE

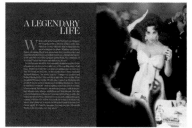

6-7: John Bryson/Time & Life Pictures/Getty Images

THE MOST BEAUTIFUL WOMAN IN THE WORLD

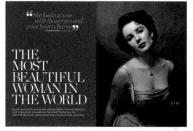

8-9: Philippe Halsman/©Halsman Archive; **10-11:** Kobal; ©Sid Avery/ MPTV; **12-13:** ©Eric Skipsey/ MPTV; ©Mark Shaw/MPTV; **14-15:** ©Bob Willoughby/MPTV; Kobal; **16-17:** Douglas Kirkland/ Corbis; Rex USA; **18-19:** Douglas Kirkland/Corbis; **20-21** Everett; Getty Images; **22-23:** Frank Teti/Neal Peters Collection; Francesco Scavullo Foundation; **24-25:** Herb Ritts/Lime Foto; Michel Comte/Corbis Outline

SWEET BIRD OF YOUTH

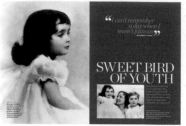

26-27: MPTV; Everett; **28-29:** Clockwise from top left: Hulton Archive/Getty Images; Everett; Evening Standard/Hulton Archive/ Getty Images; **30-31:** Clockwise from left: Peter Stackpole/Time & Life Pictures/Getty Images; Hulton Archive/Getty Images; Bettmann/ Corbis; **32-33:** Clockwise from top left: Bettmann/Corbis; Davis Boulton/Kobal; CBS/Landov

I DO! I DO!

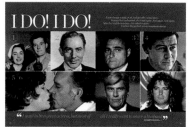

34-35: Clockwise from top left: Keystone/Getty Images; Hulton Archive/Getty Images; KPA/Zuma; Ray Fisher/Time & Life Pictures/ Getty Images; Barry King/Getty Images; Terry Ashe/Time & Life Pictures/Getty Images; Neal Peters Collection; **36-37:** Bettmann/Corbis; **38-39:** From left: Hulton Archive/ Getty Images; Keystone/Zuma; MPTV; **40-41:** Clockwise from left: Everett; Toni Frissell/Time & Life Pictures/ Getty Images; Bettmann/Corbis; **42-43:** Clockwise from right: Art Shay/Time & Life Pictures/Getty Images; Zuma; Bettmann/Corbis; **44-45:** Dalmas/Camera Press/Retna; **46-47:** Clockwise from left: Kobal; Express/Hulton Archive/Getty Images; Gjon Mili/Time & Life Pictures/ Getty Images; **48-49:** Bob Penn/ Sygma/Corbis; **50-51:** Clockwise from top left: Henry Clarke/Condé Nast Archive/Corbis; Photofest; Publifoto Milan/Ipol/Globe; **52-53:** Clockwise from top left: Bettmann/Corbis; Terry O'Neill/Camera Press/Retna; Jim Moore/Liaison/Getty Images; **54-55:** Harry Benson(2)

PULP FICTION

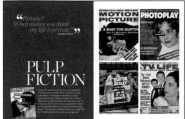

56-59: Neal Peters Collection(15)

TAYLOR MADE

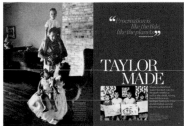

60-61: From left: Toni Frissell/ Time & Life Pictures/Getty Images; Hulton Archive/Getty Images; **62-63:** From left: Ipol/ Globe; Toni Frissell/Time & Life Pictures/Getty Images; **64-65:** Clockwise from left: Henry Clarke/Conde Nast Archive/Corbis; Everett; Bettman/Corbis; Gianni Bozzacchi/Forum Press/Rex USA; **66-67:** Clockwise from top left: William Lovelace/Express/Getty Images; Bob Penn/Camera Press/ Retna; ©Bob Willoughby/MPTV

SCREEN QUEEN

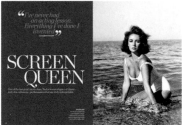

68-69: MPTV; **70-71:** From left: Kobal; MPTV; **72-73** Clockwise from left: Hulton Archive/Getty Images; John Springer Collection/Corbis; Hulton Archive/Getty Images; **74-75:** Clockwise from top left: Zuma; © 1987 Seita Ohnishi/Oscar for Jimmy, Inc., Photo by Sanford Roth; ©Sid Avery/ MPTV; **76-77:** From left: Frank Shugrue/Kobal; ©Bob Willoughby/ MPTV; **78-79:** From left: Everett; Jerry Tavin/Everett; **80-81:** Clockwise from top left: Bettmann/Corbis; Howell Conant/Bob Adelman Books; Keystone/Hulton Archive/Getty Images; **82-83:** Clockwise from top left: SMP/Globe; Ralph Crane/Time & Life Pictures/Getty Images; Everett

THE JET-SETTER

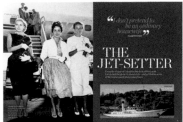

84-85: From left: Bettmann/Corbis; Rex USA; **86-87:** Bettmann/Corbis; **88-89:** Clockwise from top left: Tim Anderson/Rex USA; Jack Carter/ Zuma(3); Dave Parker/Alpha/Globe; **90-91:** Norman Parkinson/Corbis; **92-93:** Clockwise from top left: Andanson/ Sipa; Stanley Sherman/Getty Images; Rex USA(2); **94-95;** Clockwise from top left: Marty Lederhandler/AP; Patrick Lichfield/Camera Press/Retna; Zuma; Harry Myers/Rex USA; Richard Young/Rex USA; Ipol/Globe; Dave Caulkin/BIPNA/AP

A GIRL'S BEST FRIEND

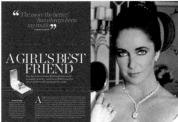

96-97: From left: Hulton Archive/ Getty Images; Gianni Bozzacchi/Forum Press/Rex USA; **98-99:** From left: Douglas Kirkland/Corbis; John Bigelow Taylor; **100-101:** from left: Kobal; John Bigelow Taylor(3); **102-103:** From left: Richard Nairin/Liaison/Getty Images; Raymond Meier/Trunk Archive; Bettmann/ Corbis; **104-105:** From left: John Bigelow Taylor; ©The Helmut Newton Estate/Maconochie Photography; **106-107:** from left: John Bigelow Taylor; Norman Parkinson/Corbis

SOUL MATES

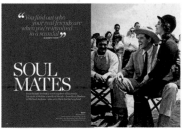

108-109: Bettmann/Corbis; **110-111:** Clockwise from right: Everett; Bettmann/Corbis; Richard C. Miller/ Richard C. Miller Photographs LLC; **112-113:** Clockwise from top left: David McGough/DMI/Time & Life Pictures/ Getty Images; Peter Stackpole/Time & Life Pictures/Getty Images; Ricki Rosen/ Saba/Corbis; Polaris; Bettmann/Corbis

THE SURVIVIOR

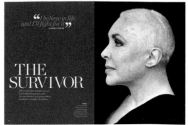

114-115: Herb Ritts/Lime Foto; **116-117:** From top: Bettmann/Corbis; AP

SECOND ACT

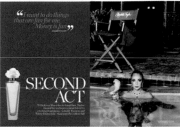

118-119: Right: ©The Helmut Newton Estate/Maconochie Photography; **120-121:** Right: Ron Galella/Wireimage

AIDS CRUSADER

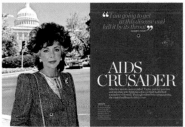

122-123: Brad Markel/Globe; **124-125:** Clockwise from bottom right: Splash News; Steve Granitz/Wireimage; DMI/Time & Life Pictures/Getty Images; Terry Ashe/Time & Life Pictures/ Getty Images

ENDPAGE & BACK COVER

128: Frank Worth/Art-Artifact **BACK COVER:** Philippe Halsman/©Halsman Archive

> "*I haven't had a quiet life. I've lived dangerously*"
>
> —ELIZABETH TAYLOR